the art of
CHINESE BRUSH

METRO BOOKS
New York

An Imprint of Sterling Publishing
387 Park Avenue South
New York, NY 10016

the art of
CHINESE BRUSH

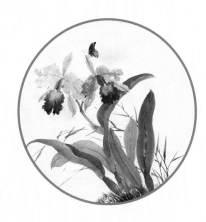

DISCOVER THE SIMPLICITY OF

CHINESE BRUSH PAINTING AND CALLIGRAPHY

Inspirational Techniques and Projects

METRO BOOKS
New York

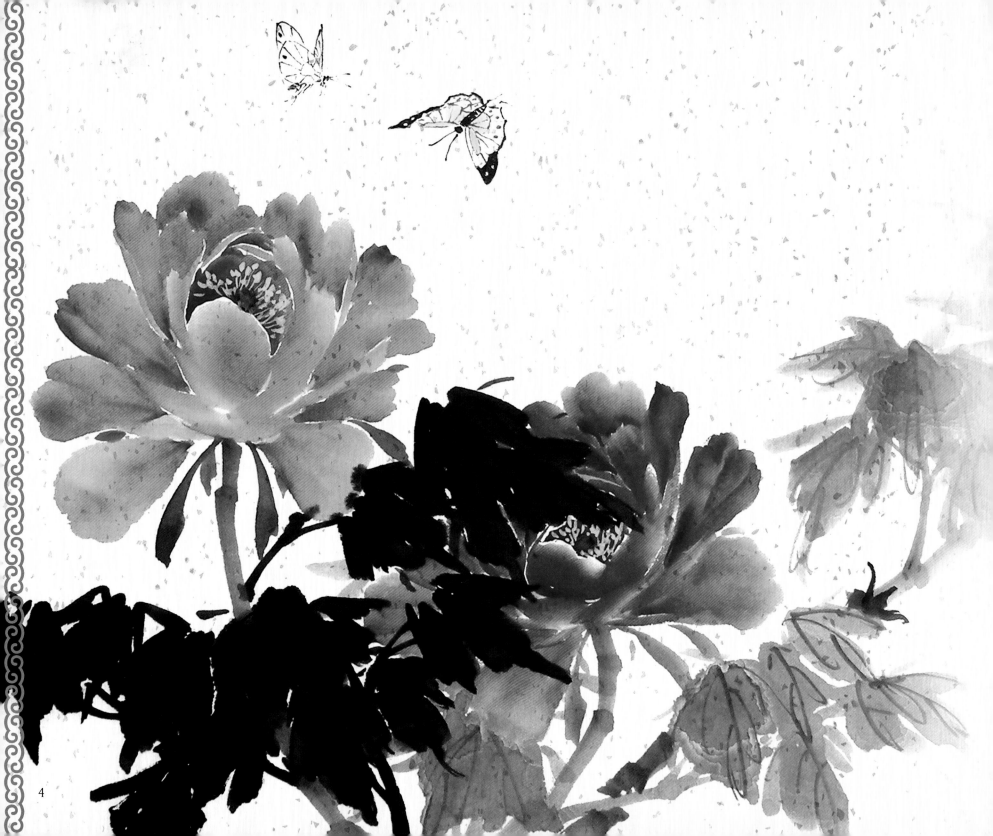

TABLE OF CONTENTS

INTRODUCTION

Chinese brush painting and calligraphy distinguish themselves from other arts because they emphasize motion and are infused with dynamic life. There is a close connection between the two art forms. Both have their roots in the pictorial representations of objects. Chinese calligraphy has been thought to be the purest form of painting, while many Chinese brush paintings contain calligraphic inscriptions. But the most fundamental similarities of traditional Chinese brush painting and calligraphy are the use of the same basic techniques and materials. The skillful use of the brush is the most important factor in both of them.

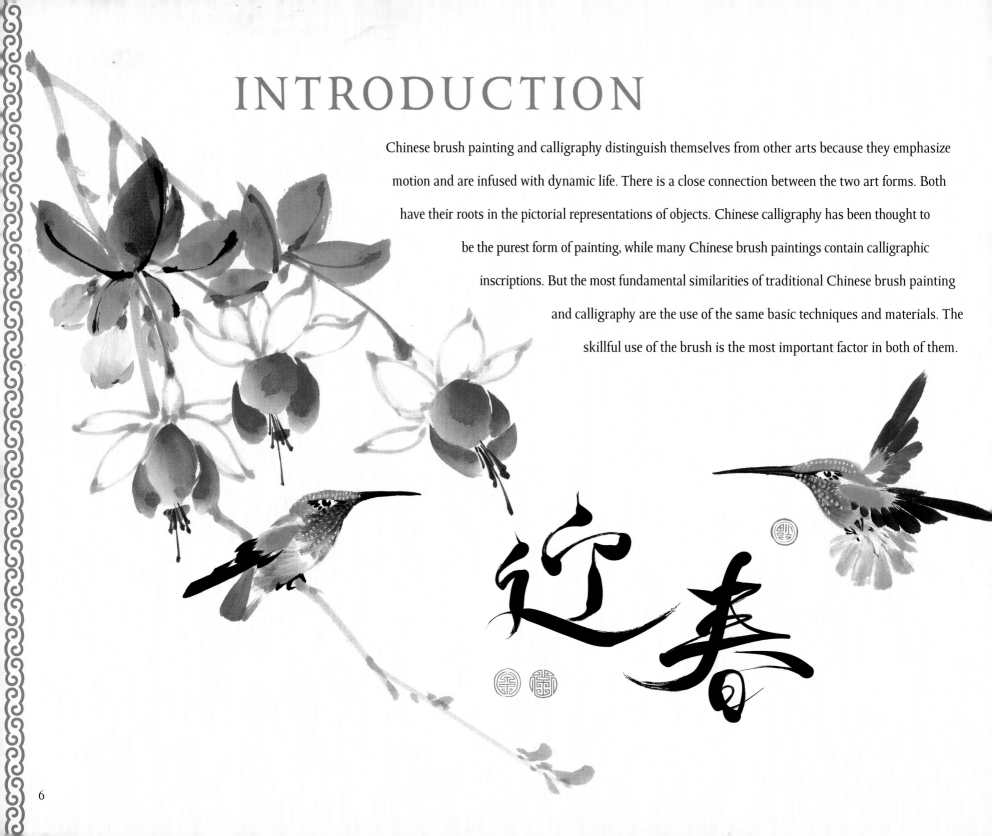

"THE FOUR TREASURES"

The key components in Chinese brush painting and calligraphy are brush, paper, ink, and ink stone. They have long been referred to in Chinese history as "the four treasures of a scholar's study." All four treasures are made from Chinese natural resources and have always played an important role in Chinese art and culture.

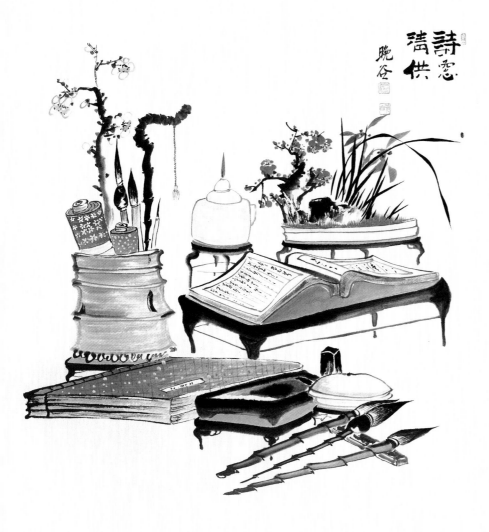

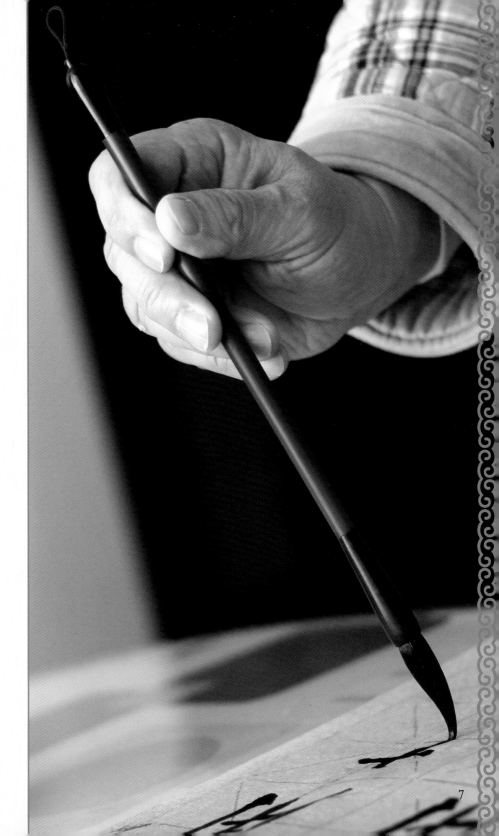

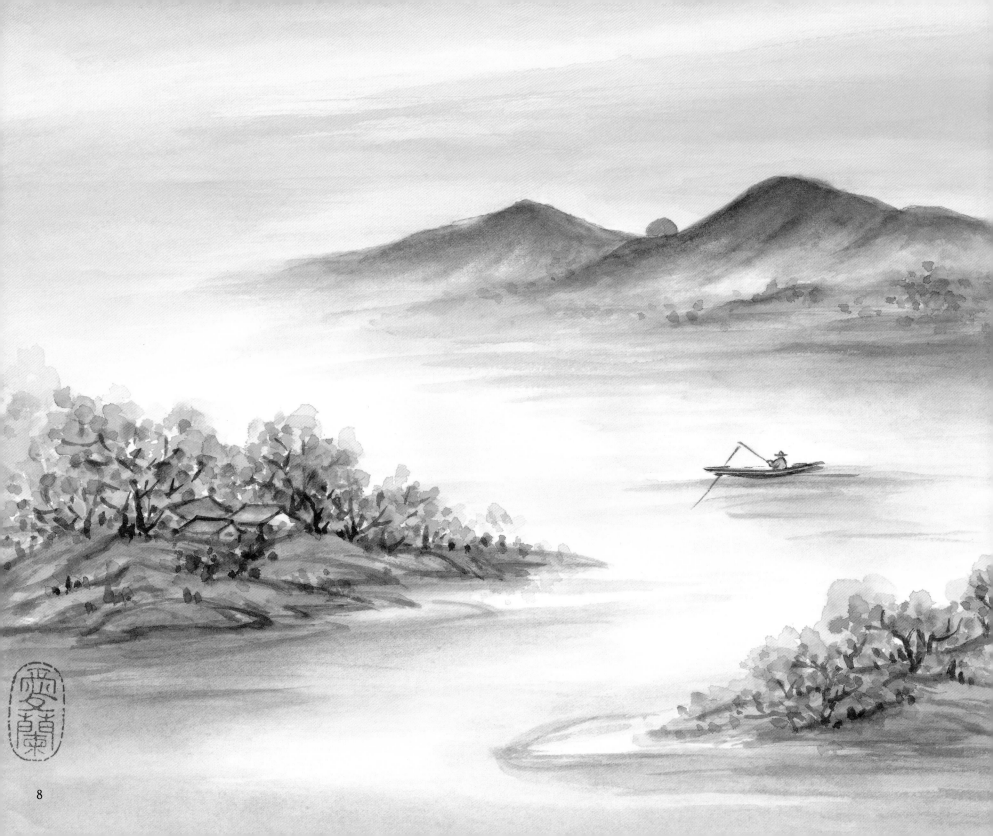

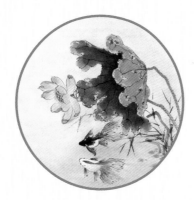

CHINESE BRUSH PAINTING

People of all cultures are drawn to the simplicity, harmony, and unparalleled grace of Chinese brush painting. Characterized by fluidity

and economy of line, this art style has a unique appearance that suggests self-discipline and spontaneity. In line with Taoist philosophy,

the focus of Chinese brush painting is capturing an object's essence rather than reproducing an object as it is seen. Chinese brush artists

therefore use brushstrokes, color, and contrast to reflect and reveal the individual character of a subject.

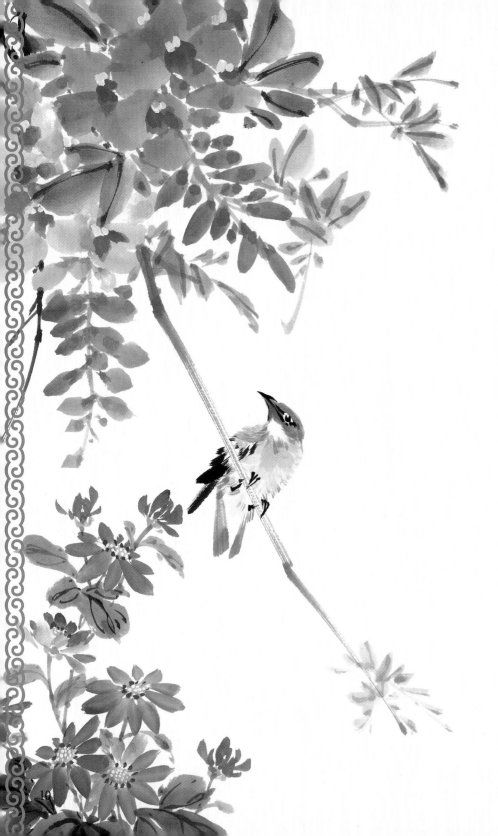

Chinese brush painting is a traditional art form that has been around for more than 2000 years. In the year 200 BCE—during the Han Dynasty—the Chinese began to record their history on sheets of silk, bamboo, and other types of wood. They applied these images using tapered paintbrushes made of wolf hair and soaked in ink made from pine soot and water. Though these first Chinese markings were not accurate representations of what they conveyed, each symbol suggested an object, action, or idea within its strokes. It was from this early form of calligraphy that Chinese brush painting evolved, maintaining the importance of essence over realism. In the year 105 CE, the invention of paper brought new possibilities to the art form, offering a thin, absorbent surface for painting. The availability and convenience of paper also helped Chinese brush painting flourish.

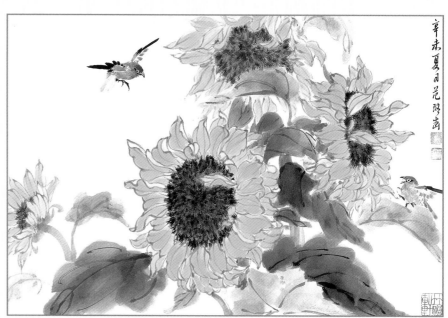

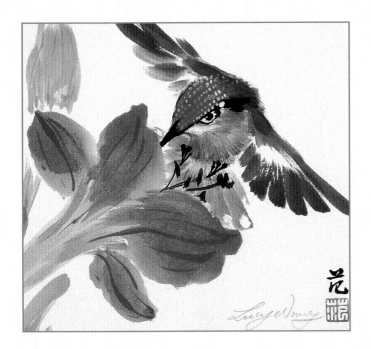

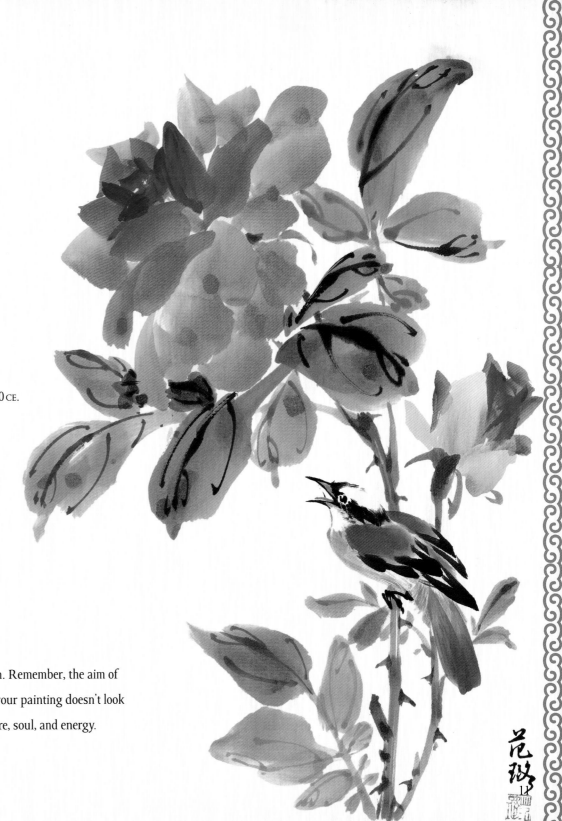

The first account of Chinese brush painting theory surfaced shortly after 500 CE. One of the great masters of the art, Hsieh Ho, formulated six tenets that are still respected and followed today. The basic principles are:

1. Enliven the painting with a sense of spirit.

2. Use brushstrokes as a means to suggest character.

3. Understand the natural form of the subject.

4. Apply color that is appropriate for the subject.

5. Create a skillful arrangement of the objects and empty space.

6. Copy and pass on the methods of past masters.

Keep these six principles in mind as you complete the projects in this section. Remember, the aim of Chinese brush painting is to portray an essence, so don't be discouraged if your painting doesn't look completely realistic or lifelike; focus instead on capturing the subject's texture, soul, and energy.

TOOLS AND MATERIALS

The art of Chinese brush painting requires four main materials: a Chinese paintbrush, paper, ink, and an ink stone. Called "The Four Treasures" of an artist's studio, these items cover the basics, but there are also several other items that you will need to gather before you begin. When you purchase your supplies, try to buy the best you can afford; better quality products are easier to work with and provide better results than less expensive tools do.

INK STICK AND INK STONE

The ink for Chinese brush painting comes in the form of a hard stick; it is liquefied with water and ground on the stone. To use an ink stone and ink stick, put about one teaspoon of fresh water in the well of the stone. Then, using a circular motion, quickly grind the ink stick against the bottom of the well of the stone for about three minutes, or until the water becomes thick and dark black. Before each use, make sure your stone is clear of dry ink. Always use fresh water each time you paint, and always grind the same end of the ink stick.

CHINESE PAINTBRUSHES

The bamboo brushes used for Chinese brush (sometimes sold under the name "sumi" brushes) are similar to watercolor brushes, but they have bristles that taper to a finer tip. There are two types of bamboo brushes: stiff and soft. The stiff, brown-bristled brushes are more versatile and resilient, making them good for painting leaves and branches. The soft, white-bristled brushes have more flexible bristles, which make them ideal for painting large areas of color and for depicting soft textures, such as animal fur and petals. For best results, use the brushes recommended in each project and that fit the size of your subject. New brushes have sizing in the bristles—a substance that keeps the bristles in their desired shape. Soak your brushes in water to remove the sizing before use.

BRUSH REST

A brush rest is used to keep the bristles of your brushes protected between uses. Chinese brush rests come in many different styles and are often made of ceramic or metal. Choose whichever type you prefer.

MIXING PALETTE

Mixing palettes are helpful for diluting your colors and for holding washes for dipping and tipping (see page 17). You can also use the sides of the palette wells to help shape the bristles into flattened points. Mixing palettes come in various shapes (round, oval, rectangular, and square) and can be made of a variety of materials (plastic, ceramic, glass, or metal). Plastic palettes are lightweight and reasonably priced, but all types clean up easily with soap and water.

WATERCOLOR PAINTS

Watercolor paints are often used to add color to Chinese brush paintings. Watercolors are available in several forms and in a range of colors. Tube paints are a popular choice, as they come already moist and ready to use. Just squeeze each color onto a palette well or small dish, and mix it with water to create a wash; the less water there is in the mixture, the more intense the color will be. Pan and cake paints are dry blocks of pigment. To use these paints, add water to loosen the pigment and load your brush with color. Pan colors packaged in a box are convenient, but if you want to mix a lot of color at one time, tube paints are a better choice; you can squeeze out a large amount of pigment quickly and easily.

PAPERS

You can use many different types of papers for Chinese brush painting. Newsprint is great for practice because it is both absorbent and inexpensive. Watercolor paper is a wonderful painting surface for final artwork because it's versatile and easy to paint on; the paper absorbs the paint just enough without allowing the colors to bleed. Watercolor paper comes in a variety of textures (also called the "tooth"), ranging from coarse to smooth. The three surfaces shown below are the most common. From top to bottom, they are rough, cold-press (medium texture), and hot-press (smooth). As you progress, you may want to try painting on rice paper—the primary painting surface of Chinese

brush painters for more than 2000 years. But Chinese brush painting is not limited to paper; you can produce similar fluid effects with surfaces such as wood, pottery, fabric, and silk.

WATER DISH

Chinese brush artists often use small ceramic dishes to hold clean water for dipping, like the one shown to the right. You should also have an additional jar or bowl for rinsing your brushes between colors. Unless you are double-dipping your colors as directed in a project, always rinse your brush well between colors, and set your brush on a rest when not in use; never let your brushes stand in water.

OTHER MATERIALS

Aside from the actual painting tools, there are a few extras that will come in handy. Paper towels are great for drying and blotting brushes, as well as for testing colors. You may want to place your paper on felt or use a paperweight to hold it still while you paint to prevent the paper from shifting and curling. To erase any mistakes you make while pencil sketching, use a kneaded eraser rather than a rubber one; kneaded erasers won't damage the surface of the paper, as rubber erasers are prone to do.

BASIC COLOR PALETTE

Choosing colors can be daunting to beginners, but you don't need to purchase a great array of watercolors to enjoy Chinese brush painting. Just a few basics to add to your black ink will do, and you can always mix just about any other color you may need from these few. Your basic palette of colors should include at least one or two (a warm and a cool version) of each of the primary colors (see page 14), as well as brown and white. As you refine your brush-painting skills and branch out into new subject areas, you will develop your own color preferences. The colors listed below will get you started and are all you need to complete the projects in this section.

- *Chinese white*
- *lemon yellow*
- *vermilion*
- *crimson red*
- *cadmium red*
- *deep green*
- *viridian green*
- *ultramarine blue*
- *cobalt blue*
- *indigo blue*
- *burnt sienna*

COLOR THEORY AND MIXING

You have already learned that the aim of Chinese brush painting is to convey the essence of a specific subject, and an effective means of capturing this "feeling" on paper is through color. Each color or combination of colors that you select for a subject suggests a particular mood to the viewer; a painting full of reds evokes passion and anger, and a painting made up of soft blues and greens elicits a sense of serenity. Therefore your choice of colors is the key factor in determining whether your painting is a bold, warm piece or a subtle, cool piece (see "Color Psychology"). A basic knowledge of color theory will help you achieve the precise mixes you need for your paintings.

COLOR BASICS

The color wheel provides the perfect starting point for understanding the relationships between colors, which will help you produce the effects you desire. The primary colors (red, yellow, and blue) are the three basic colors that can't be created by mixing other colors. All other colors are derived from these three. Each combination of two primaries results in a secondary color (purple, orange, or green), and a combination of a primary color and a secondary color results in a tertiary color (such as red-orange or red-purple). On the color wheel, at right, the two across from each other are complementary colors; they enhance one another when placed together. Groups of adjacent colors are analogous colors; when they are used together in a painting, they create an overall feeling of harmony.

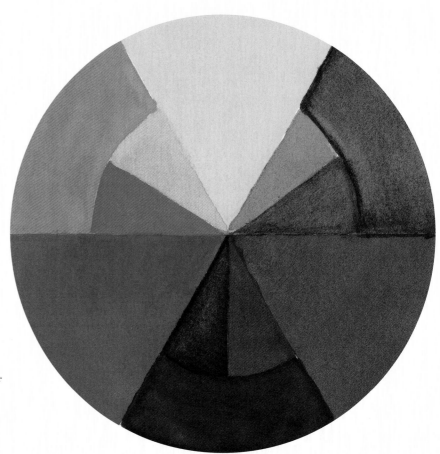

COLOR WHEEL ▶

The color wheel is a helpful visual reference that demonstrates color relationships. Knowing the basics of these relationships will help you control the mood and create a sense of unity in your paintings.

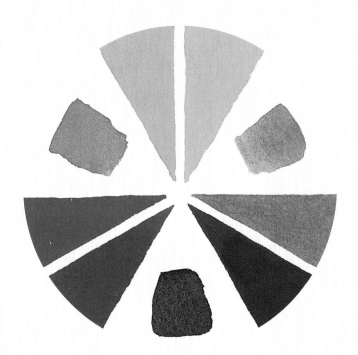

COLOR PSYCHOLOGY

Colors are often classified figuratively in terms of temperature. The "warm" colors are reds, oranges, and yellows, and the "cool" colors are greens, blues, and purples. But there are variations in temperature within every family of color, or hue, as well. A red that contains more yellow, such as cadmium red, is warmer than a red that has more blue, such as alizarin crimson. The temperature of the colors you use can express a mood, season, or the time of day. For example, light pinks, blues, and greens can effectively suggest the fresh air and blooming nature of spring.

◀ MIXING VIVID SECONDARY COLORS

When mixing two primaries to produce a secondary color, you will find that the result varies depending on the hues you choose to mix. Remember that the most vibrant secondary colors are made by mixing two primaries that have the same temperature (i.e., two cools or two warms).

USING WATERCOLOR PAINTS

Watercolor paint needs to be thinned with water before use. The more water you add, the lighter the color will become, as shown below. To complete the projects in this section as demonstrated, you'll also have to mix paint colors. For example, you can produce a vibrant purple by mixing magenta and ultramarine blue washes. When the project calls for a color not provided in a tube, you will be told which colors to combine to create the desired color.

CREATING A VALUE SCALE

Throughout this section, colors are sometimes described as "dark," "light," or "medium." When a project calls for a "dark" (or "strong") color, use very little water; for a "light" color, add a lot of water so the color is very light; and for a "medium" color, add enough water to achieve a color somewhere between dark and light. Making value scales like the one above will help you get to know the proportion of water to paint needed to create the desired value.

HANDLING THE BRUSH

Chinese brush painting is known around the world for its graceful and expressive brushstrokes. To create the fresh and flowing lines, it is important that you hold the brush correctly. Sit up straight and lay the paper on your table or work surface. Place a piece of felt beneath your paper to keep it from sliding and to protect your table. Then practice making the various strokes on these pages using the vertical and slanted holds shown below. These positions may seem awkward at first, but once you get used to them, you will be able to form the strokes correctly.

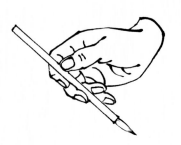

SLANTED HOLD

Hold the brush so it's almost parallel to the paper, and use your thumb and fingers to control the movement of the brush, as shown. The width of the stroke is determined by the angle of and the pressure on the brush. The shape of the stroke is determined by movement of the brush: press and lift, push and pull, turn and twist, or dash and sweep.

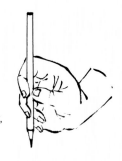

VERTICAL HOLD

Hold the brush so it's perpendicular to the paper. Grasp the handle just below center, placing it between your thumb and index finger and resting the lower part on the nail of your ring finger. Rest your middle finger on the handle just below your index finger. Support your third finger with your pinkie, and brace the handle with your thumb.

CREATING STROKES

Each stroke requires one fluid movement—press down, stroke, and lift. All your brushstrokes should move in a definite direction; you should always be either pushing or pulling your brush. Use your second finger to pull and your third finger to push. Hold the brush gently, letting it lightly touch the paper. Pressing too hard releases too much ink and makes the strokes difficult to control. Practice applying only as much pressure as is needed to create the shape and width of your brushstrokes. It is important to thoroughly practice each stroke and brush position before you begin following the lessons in this section; Chinese brush painting calls for a minimal number of strokes, so each one must be carefully and confidently placed.

SLANTED STROKES

Hold the brush almost parallel to the paper and, in one smooth movement, press down, stroke, and lift, using your thumb and fingers to control the movement of the brush. Use slanted strokes to paint large areas and thick shapes.

VERTICAL STROKES

Hold the brush perpendicular to the paper and stroke from top to bottom, thickening your line by gradually pressing the brush down on the paper. Because this stroke can produce thin lines, it is perfect for outlines, branches, clothing, and other detailed lines.

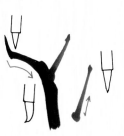

BRUSH TIPS

For a flat, dry stroke (near right), dip your brush in color and then press the tip of the brush against the side of a dish or on a paper towel to flatten it and remove excess moisture. Use a flat tip for feathers and flower petals. For a pointed stroke (far right), dip your brush in color and paint with the very tip of the brush. Use a pointed tip for thin lines and details.

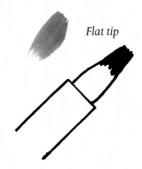

Flat tip

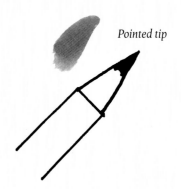

Pointed tip

TIPPING THE BRUSH

The basic method used in this section for mixing colors on your brush is called "tipping." Start by dipping or fully loading your brush with the first color; then touch the tip of the bristles into the second color. When stroked on the paper, your dipped brush will leave behind an interesting blend of the two colors.

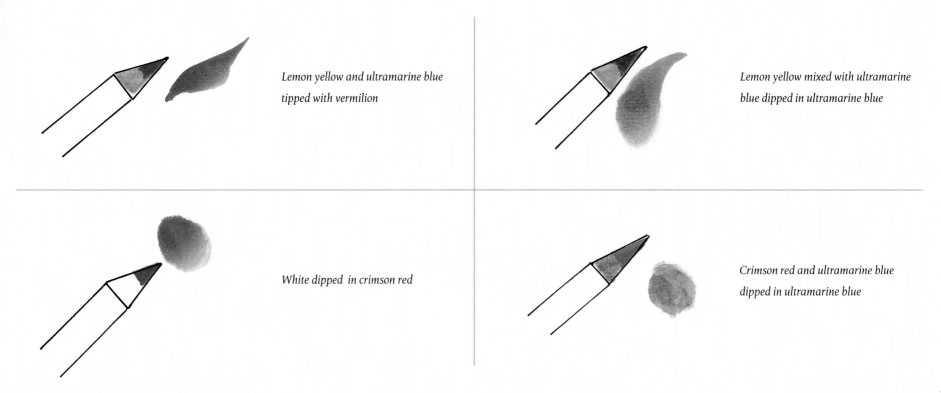

Lemon yellow and ultramarine blue tipped with vermilion

Lemon yellow mixed with ultramarine blue dipped in ultramarine blue

White dipped in crimson red

Crimson red and ultramarine blue dipped in ultramarine blue

BASIC STROKES

Chinese painting strokes were developed from the strokes of traditional calligraphy (Chinese writing) thousands of years ago. There are three basic strokes derived from calligraphy that you will use throughout this book: the water-drop stroke, which is made by holding the brush in the slanted position, and the bone stroke and the hook stroke, which are both made by holding the brush vertically. Below are a few examples of eight different variations of these strokes for you to follow and practice—remember to keep your wrist and hand loose and flexible as you paint!

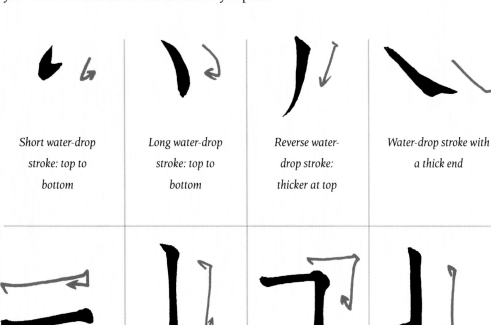

Short water-drop stroke: top to bottom

Long water-drop stroke: top to bottom

Reverse water-drop stroke: thicker at top

Water-drop stroke with a thick end

Horizontal bone stroke

Vertical bone stroke

Combined vertical and horizontal bone strokes

Hook stroke: vertical line with a water-drop stroke at the end

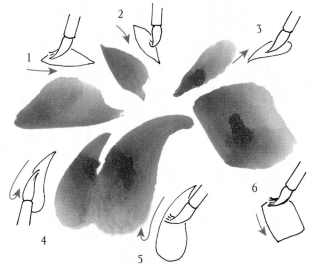

PETAL AND LEAF STROKES

Follow the arrows with your brush to re-create each brushstroke. For thicker lines, press down harder on the brush; for thinner lines, use a lighter touch.

1. Triangle (press down at start, lift for tip)
2. Reverse teardrop (touch tip of brush from top and press down to paper, lifting for tip)
3. Teardrop (press entire brush to paper and lift without moving the brush)
4. Short water-drop
5. Long water-drop
6. Rectangular (even stroke, top to bottom)

PRACTICING STROKES

Because the simplicity of this art form requires a minimal number of strokes, each one must be placed carefully. Every stroke should be made up of one fluid movement—press, stroke, and lift. Begin by loading a medium brush with an ink wash and experiment with the amount of pressure you place on the brush. You'll notice that you need only a light touch; pressing too hard releases a lot of ink or paint from the bristles and can cause unwanted pools of pigment. (If this occurs, you can dab up the pools with tissue or a paper towel.) However, using different amounts of pressure varies the thickness of your strokes, so you'll want to discipline your hand to achieve consistent results.

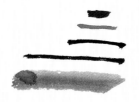

LINE STROKES

Pull the brush across the paper in a straight line, pausing briefly at each end. This will cause the ends to be a bit heavier than the majority of the stroke.

LONG DOT STROKES

Hold the brush at an angle to your paper and press down with the point. Vary the position of the brush to create dots in different directions.

DOT STROKES

Hold the brush upright and press down only the very tip onto the paper. The less pressure you apply, the smaller the resulting dot will be.

RICE STROKES

For strokes shaped like grains of rice, hold the brush at an angle to the paper. Touch the bristles to the painting, make a short stroke, and lift.

CURVE STROKES

Holding the brush at an angle to the paper, press down the tip and make a small swoop with your brush as you stroke.

BLEND-AND-TIP STROKES

Dip your brush in one color; then dip only the tip in another color (called "tipping"). Your stroke will show a gradation of the two colors.

SIDE STROKES

For wide strokes, hold the brush at an angle to the paper and paint with the body of the brush. Lift up at the end for a narrow finish.

PRESS-AND-LIFT STROKES

Press the brush down to the paper, spreading out the bristles as you move. When you lift the brush, the bristles spring back, resulting in a thinner stroke.

HOW TO USE THIS SECTION

Professional Chinese brush painter Lucy Wang will now guide you step by step through a delightful collection of subject matter, from a Calico cat to a traditional Asian landscape. With easy-to-follow instructions, helpful tips, and plenty of inspiration to guide you along the way, you'll soon be creating captivating Chinese brush paintings.

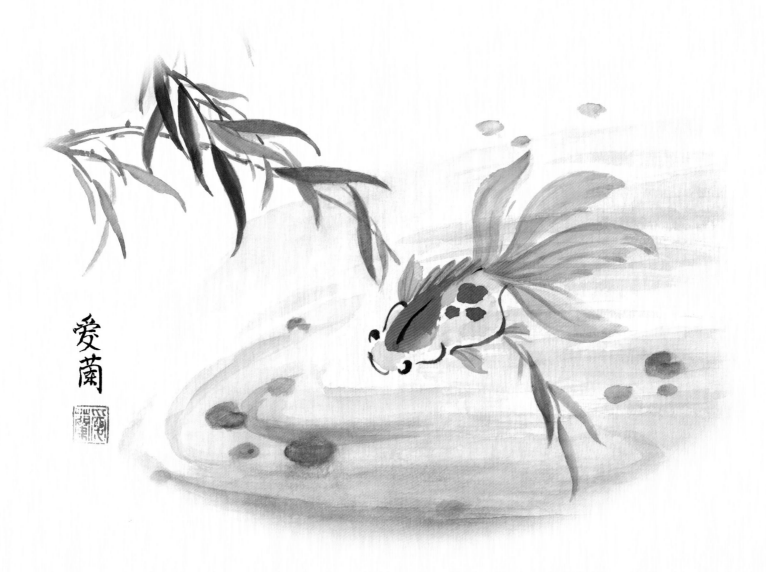

WARMING UP

Use the strokes you've learned on the previous pages to complete the following exercises. First follow the steps with your eyes, trying to distinguish the various strokes that make up each step; then practice replicating the subjects on your own.

BAMBOO

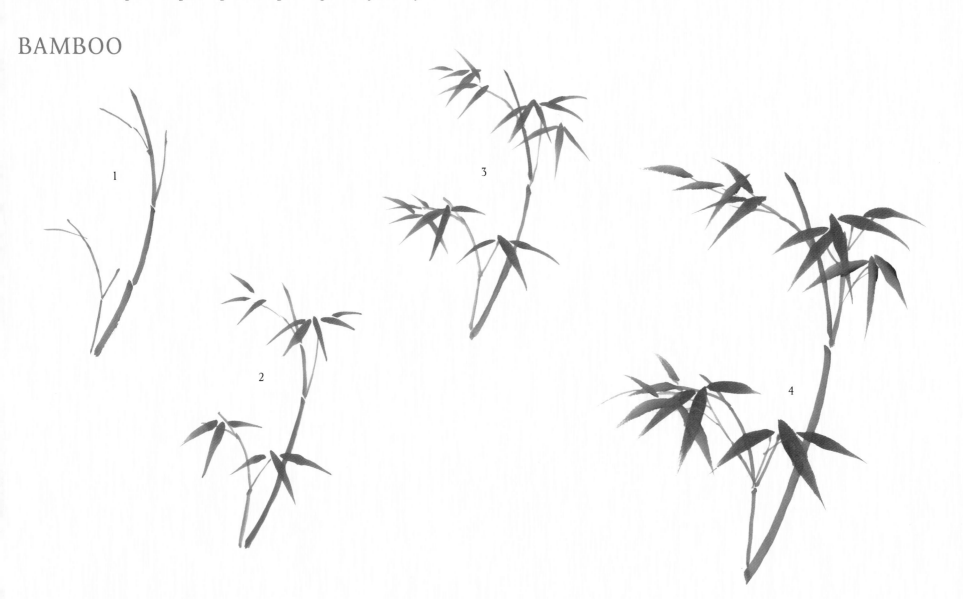

BAMBOO

Bamboo was one of the first subjects to be studied and painted in the Chinese style, so it is fitting that you should begin your practice and preparation with this traditional Chinese plant. Bamboo provides an excellent starting point; the tall, sectioned stalk and long leaves can be easily re-created using the three basic strokes of Chinese brush painting: the bone stroke, the water-drop stroke, and the hook stroke.

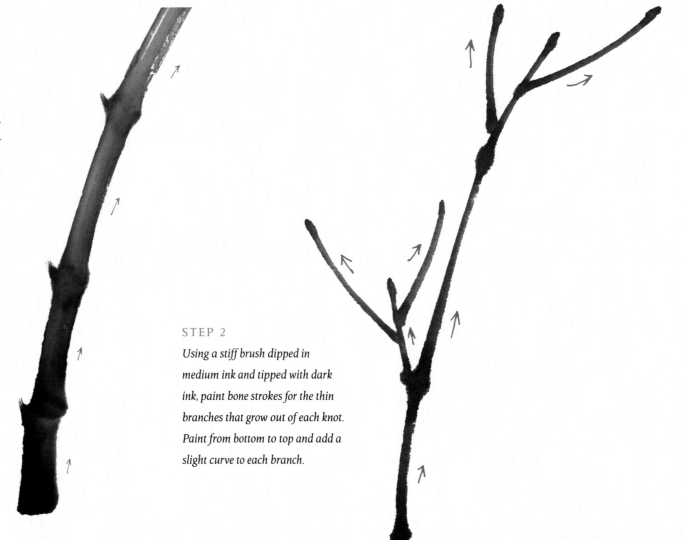

STEP 1

First saturate a stiff brush with light ink and tip it with dark ink. Then, to paint each section of the stalk, move the brush from the bottom to the top without lifting it off the paper. At the end of each section, stop the brush and lift as you drag slightly to the left to create a bulge or a knot.

STEP 2

Using a stiff brush dipped in medium ink and tipped with dark ink, paint bone strokes for the thin branches that grow out of each knot. Paint from bottom to top and add a slight curve to each branch.

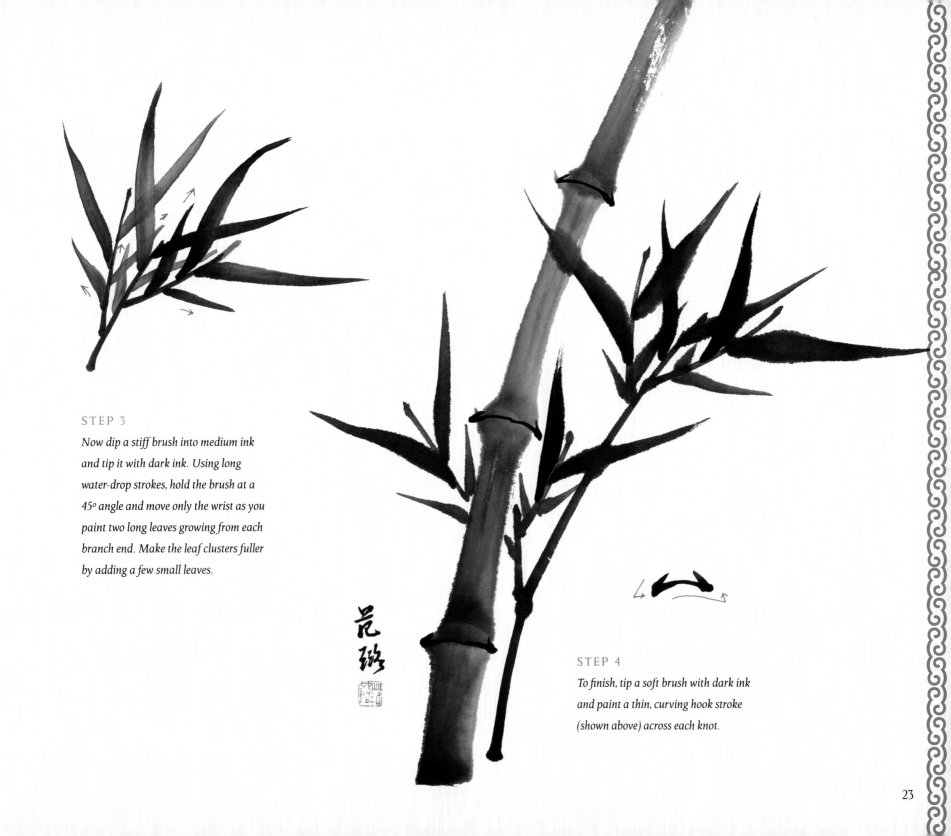

STEP 3

Now dip a stiff brush into medium ink and tip it with dark ink. Using long water-drop strokes, hold the brush at a 45° angle and move only the wrist as you paint two long leaves growing from each branch end. Make the leaf clusters fuller by adding a few small leaves.

STEP 4

To finish, tip a soft brush with dark ink and paint a thin, curving hook stroke (shown above) across each knot.

23

FLOWERS

The vibrant colors and soft, curving forms of flowers make them a favorite subject of Chinese brush painters. A great range of brushstrokes and techniques can be used to re-create the various shapes and textures of leaves and petals. Follow the demonstrations below to learn the methods for painting three distinct flowers. This is the first exercise that involves tipping the brush with paint. Notice how the colors interact and blend as you stroke and how the variations in tone create a sense of depth.

CAMELLIA

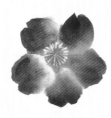

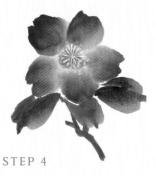

STEP 1

Load a large soft brush with a thin white wash and tip it with crimson red. Allow the wash to mix on the brush and then paint two water-drop strokes side by side for each petal, moving from the outer tip of the petal toward the center.

STEP 2

Paint five petals in a circular formation to develop the flower, leaving the center unpainted. You may want to rotate the paper as you complete each petal; this way you will not have to change the angle and direction of your strokes.

STEP 3

Now load a soft brush with a wash of lemon yellow and deep green and fill in the flower's center. Using a detail brush loaded with thick Chinese white, paint the stamen with thin bone strokes from the tips to the center.

STEP 4

Using a very small brush tipped with thick yellow paint, apply dots of pollen in the center of the flower, around the tips of the stamen.

PAINTING LEAVES AND STEMS

For a blue-green leaf, mix lemon yellow and deep green and load a small stiff brush; then tip it with ultramarine blue and paint two short water-drop strokes. Repeat this process with yellow-green tipped with burnt sienna for a browner leaf, and use less blue for greener leaves. Use a very small brush tipped in a yellow-green wash to paint the stem with bone strokes.

POINSETTIA

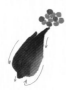
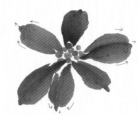
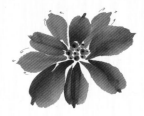

STEP 1

Soak a small stiff brush with a mix of lemon yellow and deep green and tip it with ultramarine blue. Paint a cluster of four round buds, then tip the brush with yellow and add more buds to create an oval shape.

STEP 2

Using a soft brush dipped in a vermilion wash and tipped with crimson red, hold the brush at a 65° angle and paint the petals using water-drop strokes. Add a small tip to the middle edge of each petal.

STEP 3

Paint the next two petals using the same method as in step two. As you paint each petal, be sure to point the tip of the brush toward the flower's center. Again, it may be easiest to rotate the paper as you paint.

STEP 4

Add three more leaves, making each leaf a slightly different length and shape. You may have to apply more than one water-drop stroke for each petal in order to achieve the desired shape.

STEP 5

The poinsettia is a full flower, so be sure to fill in any gaps or empty spaces with petals. When you have completed the petals, paint crimson red dots on the green buds with the tip of a small stiff brush.

BIRD OF PARADISE

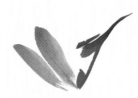
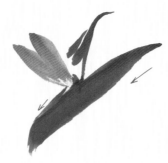
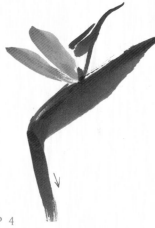

STEP 1

Dip a soft brush in vermilion and tip it with crimson red. Then hold the brush at a 65° angle with the tip facing away from you. Lift up the brush gradually while stroking toward you, controlling the brush's movement with your finger; the angle of the brush will change as it moves.

STEP 2

Load a stiff brush with blue, tip it with a small amount of crimson red, and paint water-drop strokes for the petals. Begin with the tip of the brush on the paper and gradually press down at the end. Then hold the brush vertically and add bone strokes for the stem.

STEP 3

Mix deep green and lemon yellow with a soft brush and tip it with blue. Allow the washes to blend in the brush and tip it again with crimson red. Holding the brush at a 45° angle, press down from the tip of the sepal and lift the brush up to taper the stroke and finish the sepal.

STEP 4

With the same color combination as in the previous step, hold the brush straight up and down and paint the stem with a bone stroke. To create the dry, coarse effect shown at the bottom of the stem, blot the brush on a paper towel before you stroke.

INSECTS

A common element in Chinese brush paintings, insects usually complement flowers and serve as colorful, intricate focal points. The thin lines and delicate details provide a dynamic contrast to the large, smooth areas of color used to paint flowers. Follow the demonstrations below to practice executing fine details and to gain confidence in using the very tip of the Chinese paintbrush. During this process, remember to keep a fluid simplicity to your brushstrokes and avoid overworking your insects.

BUTTERFLY

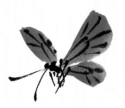 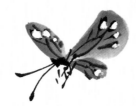

STEP 1

Use a soft brush with a light ultramarine blue wash tipped with a darker blue wash to paint three water-drop strokes toward the body.

STEP 2

Using the tip of a dry stiff brush loaded with black ink, hold the brush vertically and paint the veins of the wings with bone strokes.

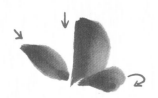 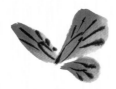

STEP 3

Holding the brush vertically, paint a dot for the body and bone strokes for the stomach. Create the legs and antennae with bone strokes.

STEP 4

To add markings to the butterfly, dot on small areas of thick white paint. Remember that a butterfly's wings have symmetrical markings.

DRAGONFLY

STEP 1

Saturate a stiff brush with burnt sienna and tip it with crimson red. Paint small water-drop strokes for the eyes and mouth. Using the same color, paint two slanted strokes for the dragonfly's thorax.

STEP 2

Using the tip of the brush, paint bone strokes from the thorax to the tip of the abdomen, making the abdomen appear to consist of several segments. The abdomen should be about five times longer than the thorax.

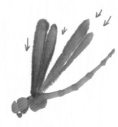 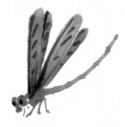

STEP 3

Load a soft brush with light ink and tip it with medium ink. Allow the ink to blend within the bristles and then blot the brush on a paper towel. Paint long, rapid water-drop strokes down toward the top of the thorax.

STEP 4

Saturate a dry stiff brush with black ink and use the tip to paint thin lines on the dragonfly's wings. Finally tip a clean, dry stiff brush with vermilion and crimson red and paint bone strokes for the legs.

BEES

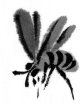

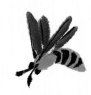

STEP 1

Create a thick yellow wash, load a small soft brush, and tip it with burnt sienna. Paint a small square shape with the tip.

STEP 2

Prepare the brush as you did in the previous step, and paint the body of the bee with a fat, rectangular water-drop stroke.

STEP 3

Tip the stiff brush with medium ink, blot it on a paper towel, and add the wings with two pairs of thin water-drop strokes.

STEP 4

Now add the eyes, antennae, and lines along the wings using a dry stiff brush tipped with dark ink.

STEP 5

Finally paint the six legs with black ink using bone strokes and the tip of a detail brush.

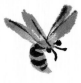

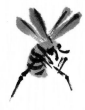

STEP 1

Dip a small soft brush in thick yellow and tip it with burnt sienna. Using only the tip, paint a small square shape.

STEP 2

Load the brush again as you did in the previous step. Then paint the bee's body with one small, fat water-drop stroke.

STEP 3

Using a dry stiff brush tipped with medium ink, paint two water-drop strokes on each side of the body for the wings.

STEP 4

Use a dry stiff brush and dark ink to paint the eyes, antennae, and lines along the wings. Add stripes on the body.

STEP 5

Load a very small, dry brush with black ink, blot it on a paper towel, and use the tip to paint six legs with bone strokes.

After completing a painting, Chinese brush artists often sign their work with calligraphy and an imprint of their personal seal. The calligraphy can include many things, such as a poem about how the artist feels about the painting, the date, the season, or just the artist's signature. The seal is made from jade, stone, or ivory, and when it is carved, it breaks slightly, so no two seals can ever be exactly alike. This makes the seal as unique to an individual as a fingerprint. The painting above includes the signature and seal of the artist, Lucy Wang.

FISH

STEP 1

To paint the body of the fish, load a stiff brush with a vermilion wash and tip it with crimson red. Hold the brush at a 45° angle and swish it in a smooth stroke from the head to the tail, gradually lifting the brush up as you stroke. The curve of the stroke will suggest the movement of the fish's body.

STEP 2

With small water-drop strokes, paint two pairs of fins as shown. Then add two water-drop strokes of equal size for the tail, pressing down on the brush at the end of each tail fin.

STEP 3

Tip a stiff brush with dark ink and, holding the brush in the vertical position, paint two dots for the eyes. Then paint a dark line down the center of the back as shown.

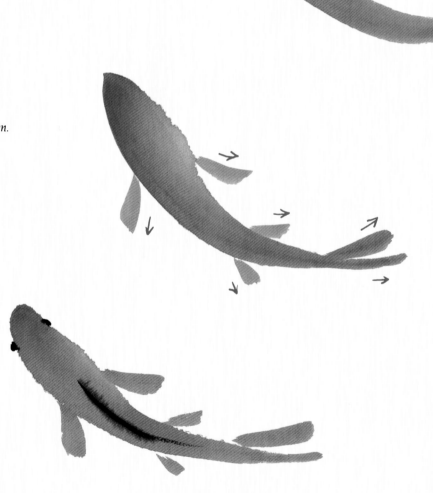

STEP 4

To make the black fish, follow the same procedure using medium ink tipped with dark ink for the body.

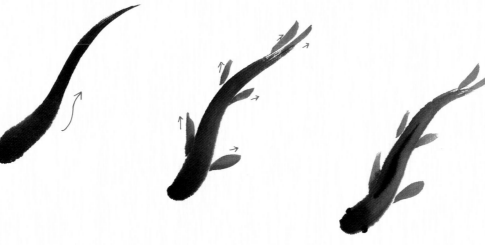

STEP 5

Now use your knowledge of painting fish to create a final composition. Fish should be painted in odd numbers or in pairs, and all the fish should swim in the same general direction. Add a few dots sparingly between the fish to suggest vegetation (see the box on the right), being careful to preserve the simplicity of the painting.

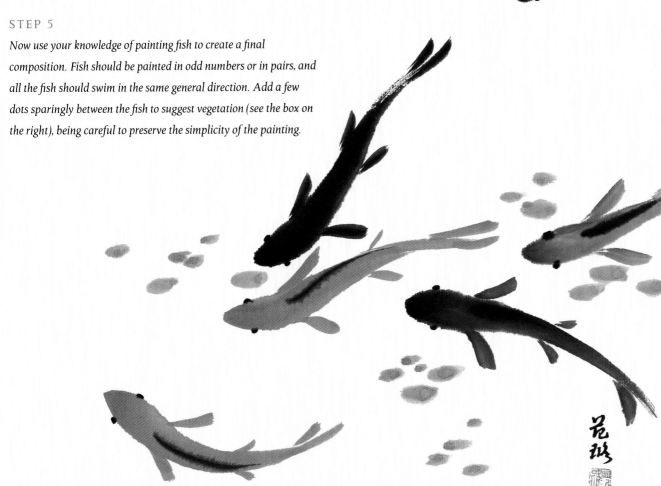

PAINTING THE VEGETATION

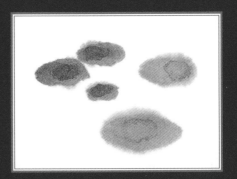

Load a small soft brush with thin deep green tipped in crimson red. Then, holding the brush horizontally, apply dots of varying size to suggest the vegetation on the water. Next mix a cooler green by adding a touch of blue to the thin green wash, and randomly apply some more dots, slightly varying the size and shape, as shown in the example. Don't add too much vegetation; you just want to create the essence of the plants to add interest to your composition.

COCKER SPANIEL

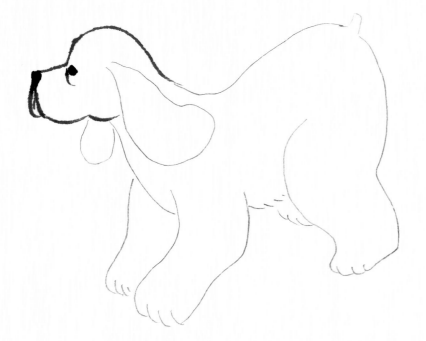

STEP 1

First lightly sketch the shape of the dog with a pencil. Then use a dry stiff brush tipped with black ink to paint a small dot for the dog's eye and a triangle pointed downward for the nose. Wash out the brush and saturate it with medium ink. Wipe the brush on a paper towel to dry it slightly, and then use the tip to outline the shape of the dog's head, holding the brush vertically.

STEP 2

Use medium ink to complete the outline of the dog's body. Keep in mind that cocker spaniels have long hair on their legs, making them look wider than they really are. To show the hair on the feet, behind the leg, and on the belly, apply a few short strokes, rather than making a smooth, continuous line.

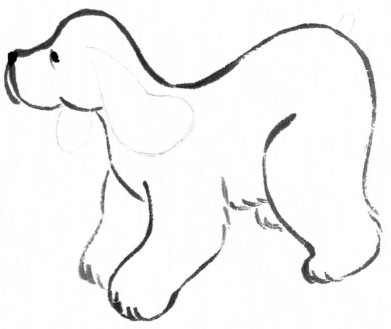

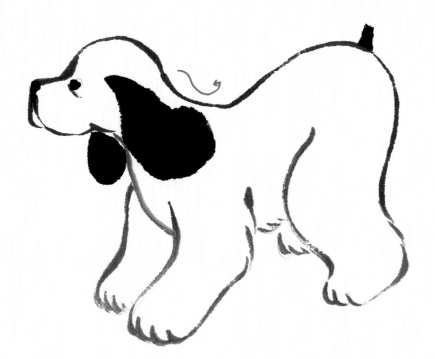

STEP 3

With a soft brush loaded with medium ink and dipped halfway into dark ink, paint a curved water-drop stroke. Start by placing the tip of the brush at the top of the dog's ear, gradually pressing down more on the brush as your hand turns, following the shape of the ear. Finally paint a short black line with the tip of your brush for the tail.

STEP 4

Soak a soft brush with medium ink and tip it with dark ink. Dry the brush slightly on a paper towel and paint the dog's coat markings using three connecting water-drop strokes for each pattern.

PANDA

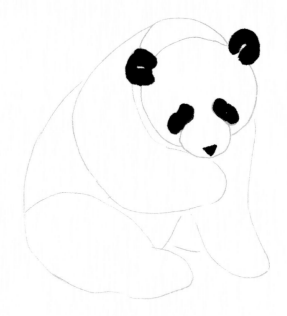

STEP 1

Begin by using a pencil to lightly sketch the shape of the panda's head, body, and limbs. Then saturate the soft brush with dark black ink and paint oval-shaped eye patches that slant at a 45° angle. Add a triangular nose and two C-shaped ears, leaving a white space in the center for the opening of the ears.

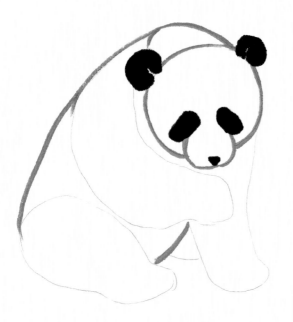

STEP 2

Next load the dry stiff brush with medium-dark ink and use it to paint a thin outline of the panda's face and body. Make sure that the wash is noticeably lighter than the dark ink used for the eye patches and ears; this will ensure that the outline doesn't stand out too much compared to the panda's markings.

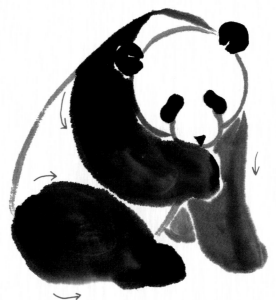

STEP 3

Next paint the front and back legs on the panda's left side using the soft brush. Saturate the brush with medium ink and dip it in dark black ink; then press down firmly. Soak the brush with dark ink and dip the tip into a small amount of water; then dry the brush on a towel to create a medium-dark ink. Now paint the two legs on the panda's right, starting from the top and moving the brush down to the end of the foot. Be sure to leave a small white gap between each leg to keep them from blending into one another.

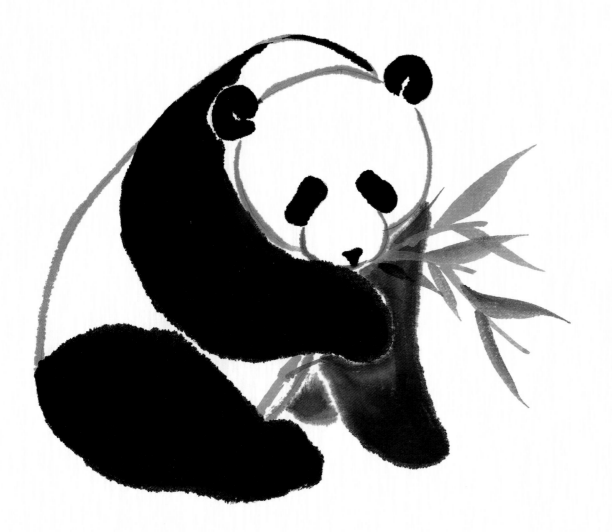

STEP 4

Now add the bamboo stalk, starting with the branch. Each branch should hold only two large and two small leaves. You may want to add another layer of black ink to the darkest areas of the panda; this will create a stronger contrast against the white.

PAINTING THE BAMBOO

Soak the very tip of the stiff brush with a light green wash and then tip it with dark green. Then use the very tip of the brush to paint thin bone strokes for the branches. Next, to form the leaves, begin with a point on the branch, press down on the brush, and quickly lift up. When making your strokes, follow the directions of the arrows in the example.

FROG

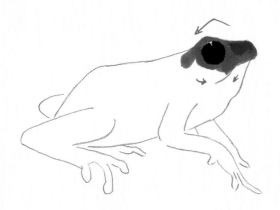

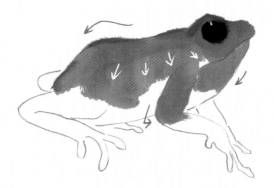

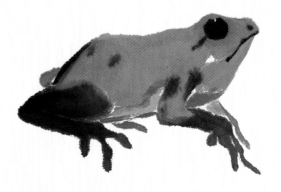

STEP 1

First lightly draw the shape of the frog with a pencil. Then use a stiff brush tipped with dark ink to paint two water-drop strokes for the circular eye, leaving a small white highlight at the top, between the two strokes. After allowing the ink to dry, saturate the soft brush with a vermilion wash and tip it with crimson red. Blot the brush on a paper towel; then paint the top of the head using water-drop strokes, surrounding the eye with color.

STEP 2

Using a soft brush dipped in a vermilion wash and tipped with crimson red, paint a long water-drop stroke from the neck to the frog's rear. Then add a series of water-drop strokes along the frog's back, sweeping downward and over the foreleg. Next saturate the soft brush with light ink tipped with a vermilion wash and paint a water-drop stroke from the chin down to the top of the chest, leaving a white spot at the corner of the frog's mouth.

STEP 3

Paint the legs and feet following the instructions in the box on page 35. Then tip a dry soft brush with light ink and fill in the empty space on the frog's chest. Rinse the brush and load it with a light wash of deep green for the frog's underside. After rinsing the brush again, load it with light ink and outline the belly of the frog. Paint two dots on the frog's backside and add spots to the forearm. Then dry the brush, tip it with dark ink, and paint a dot for the nostril. Add a thin line to define the mouth and another thin line that extends from the corner of the eye outward.

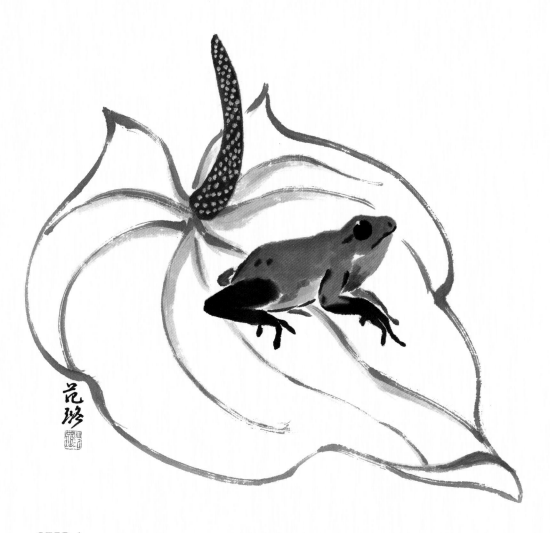

PAINTING THE FRONT LEG

Using a stiff brush dipped in light ink and tipped with dark ink, paint the remainder of the forelegs with water-drop strokes. Add the toes using small bone strokes, pressing down the brush tip at each joint. To paint the legs farthest from the viewer, use light ink.

PAINTING THE BACK LEG

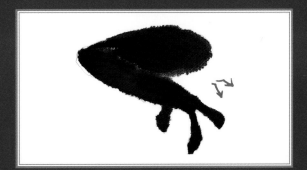

Dip the stiff brush in light ink, tip it with dark ink, and paint the hind leg with two overlapping water-drop strokes. Reload the brush and blot the excess wash on a paper towel. Holding the brush vertically, paint the toes with bone strokes.

STEP 4

Now create a background for the frog by placing him on an anthurium leaf. First add the spadix—*the curved spike at the flower's center. Saturate a stiff brush with a medium crimson red wash and tip it with a darker, thicker crimson red wash; then apply a long water-drop stroke from the top curving down to the center of the leaf. Use the point of a clean stiff brush tipped with a thick wash of lemon yellow to add equally spaced dots to the crimson spadix. Next tip a dry stiff brush with medium ink and outline the main leaf with long, gently curving strokes. Then rinse out the brush, load it with a wash of lemon yellow and deep green, and highlight areas of the outlines. Tip the same brush with a crimson red wash and add one thick stroke for the stem.*

RABBIT

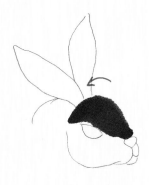

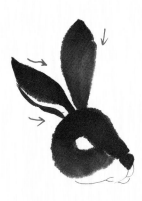

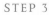

STEP 1

Load a soft brush with medium black ink and tip it with dark black ink to paint a water-drop stroke from the nose to the back of the head.

STEP 2

Then paint a water-drop stroke beginning at the left point of the first stroke and sweeping under the eye. Add a triangular nose with a brief, downward stroke.

STEP 3

Use a soft brush dipped in medium ink and tipped with dark ink to paint the rabbit's ears, using long water-drop strokes. Then add a thinner stroke that connects the tip to the base of the rabbit's right ear, leaving a slender space of white that suggests a fold.

STEP 4

Use a dry stiff brush tipped in dark ink to add the eye, leaving a space between the eyeball and the eye socket. Finally paint the mouth, cheeks, and whiskers with bone strokes using medium ink.

PAINTING THE FLOWERS

Load a soft brush with a wash of lemon yellow and deep green tipped with a pure lemon yellow wash. Hold the brush with the handle nearly parallel to the paper, press down, and lift to create the stamens of the flowers.

Dip the brush into a light wash of white, tip it with ultramarine blue wash, and then tip it again with a small amount of crimson red wash. Flatten the brush tip and paint the petals from the outer tips to the edge of the stamen.

STEP 5

Dip a soft brush in medium ink and blot it on a paper towel. Then outline the rabbit's body using curved bone strokes. Begin each stroke with pressure on the brush tip, and then lift up slightly as you pull the brush along. As each stroke comes to a finish, apply more pressure again at the tip.

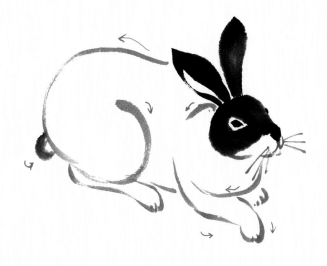

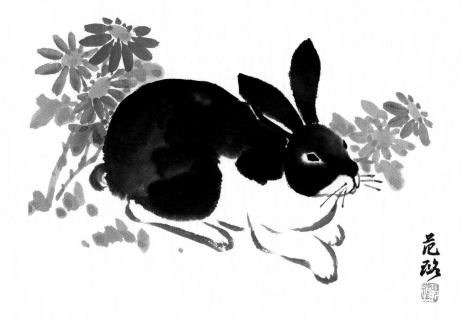

STEP 6

Load a soft brush with medium ink and tip it with dark ink. Create the rabbit's black markings with large water-drop strokes, beginning at the back and sweeping down.

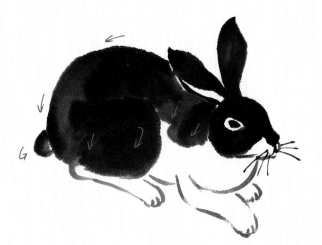

STEP 7

Finally add color and balance your painting with a few blue flowers, following the steps shown in the box on page 36 and below.

Load the brush with a wash of lemon yellow mixed with green deep; then tip it with a wash of ultramarine blue. Use thick, fat water-drop strokes to paint leaf clusters. Vary the size and shape of each leaf to add interest.

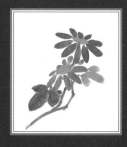

Dip the brush into a wash of lemon yellow and tip it with a crimson red wash. Use a series of thin bone strokes to create the stems. Alter the direction of the brush after each bone stroke to give the appearance of knots at the joints.

LOTUS FLOWERS AND BEES

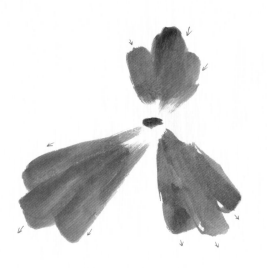

STEP 1

First sketch the lotus flower and bees in pencil. Then load a large stiff brush with a wash of lemon yellow and deep green, tip the brush with ultramarine blue, and paint a dot in the middle of the leaf. Next paint the leaf in three equal sections, using three long water-drop strokes for each section. Paint outward from the center dot, leaving a small white space between the dot and the leaf.

STEP 2

To finish the leaf, tip the brush in a yellow or burnt sienna wash (to add variety to the green) and fill in the areas between the three sections of the leaf.

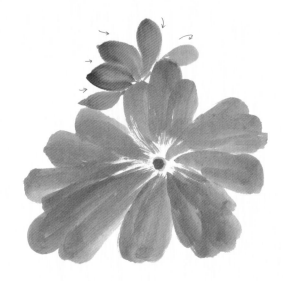

STEP 3

Now saturate a large soft brush with a thin white wash and tip it with crimson red. Then apply the front layer of the flower petals with water-drop strokes, following the directions of the arrows.

STEP 4

Tip the brush again in the crimson red wash and outline the petals that are farthest from the viewer. Now load a soft brush with a yellow-green wash and fill in the seedpod inside the flower.

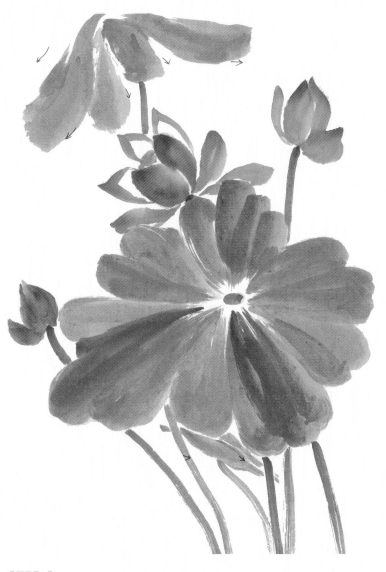

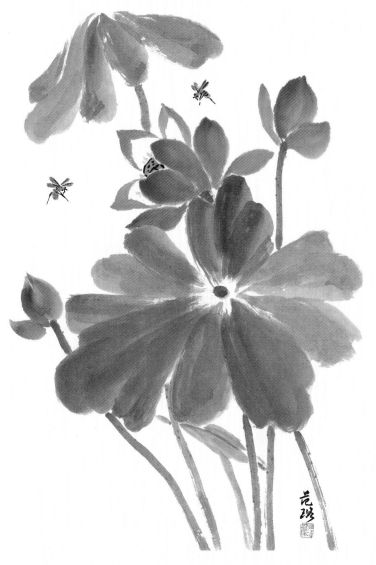

STEP 5

Still using crimson red, add the two flower buds; then tip some yellow-green on the tip of the bud on the left to indicate the seedpod. Next use a large stiff brush soaked in a yellow-green wash and tipped with ultramarine blue to paint some of the stems with long bone strokes. Paint the remainder of the stems in the same manner using a stiff brush loaded with yellow-green and tipped with crimson red. Then paint the profile of a leaf above the flowers. Add a leaf bud below the large central leaf.

STEP 6

Use a stiff brush tipped with deep green to paint dots along the stems. Next outline the seedpod with a very small brush dipped in dark ink. After rinsing out the brush, tip it with lemon yellow and paint small, fat water-drop dots for the stamens around the seedpod. Finally paint the bees by following the chart on page 27.

HORSE

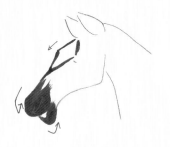

STEP 1

First sketch the horse's body in pencil. Then load a soft brush with a thinned mix of burnt sienna and medium ink, dip the tip into a pure burnt sienna wash, and paint a diamond-shaped outline for the star on the horse's forehead. Tip the brush with burnt sienna again and paint the nose with two water-drop strokes. Add another small water-drop stroke for the chin.

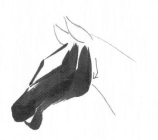

STEP 2

Now dip the tip of the brush in a burnt sienna wash and paint a long water-drop stroke with a crisp, curved edge to create the cheek. Connect the nose and chin with a short stroke.

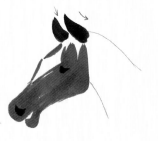

STEP 3

Next tip the brush with black ink and paint two water-drop strokes for the ears. Tip the brush with dark black ink, blot the brush on a paper towel, and paint the nostril and the eye.

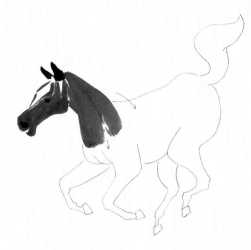

STEP 4

Rinse the brush well and saturate it with a mix of thinned burnt sienna and medium ink. Apply two long water-drop strokes from the top of the head to the bottom of the neck, using small strokes where needed to connect the neck and head.

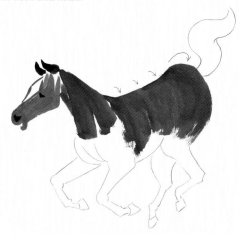

STEP 5

Load the brush with a wash of burnt sienna and medium ink and tip it with a thicker wash of burnt sienna. Holding the brush at a 65° angle, paint from the top of the back to the bottom of the horse's sides with slightly curved strokes. Leave the stomach white.

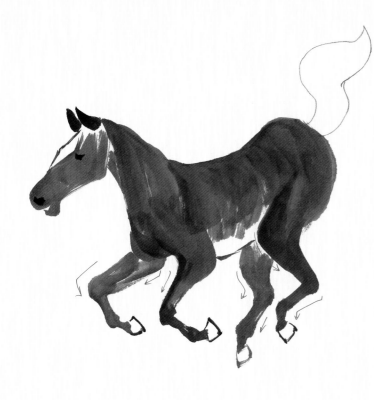

STEP 6

Now mix light ink with a wash of burnt sienna and tip the brush with black ink. Paint two water-drop strokes to create the chest. Next tip the brush with a pure burnt sienna wash and paint the horse's front left leg from the shoulder to the knee with bone strokes, turning the brush to create the lower section of the leg. When you paint the horse's knees, press down on the brush tip a bit harder to create a knotlike form. Then use the same brush to outline the horse's hoof. Paint the other legs the same way, but use a lighter wash for the two legs farthest away to suggest distance. Next add a thin stroke under the stomach.

STEP 7

Load a stiff brush with dark ink. Flatten the tip of the brush by stroking the brush along the rim of a dish or palette well. For the mane, paint strokes from the top of the neck outward, lifting the brush as you stroke to taper the ends of the hair. Next mix light ink with a small amount of burnt sienna and load the brush. Tip the brush with dark ink and paint several curved water-drop strokes, starting with the tip of the brush at the horse's rear and gradually pressing down as you stroke. At the end of each stroke, quickly lift up the brush. When you paint the background, you'll want to cover the top half of the horse with a paper towel so that you don't accidentally splash it with color. Soak the brush with a wash of deep green and hold the brush a few inches from the paper in a horizontal position. Tap the end of the brush handle with your index finger so that tiny droplets of paint spatter over the paper. Then repeat this same process using a wash of crimson red and ultramarine blue (a blue-violet color). When the colors are dry, paint horizontal strokes of a lighter wash of deep green for the ground.

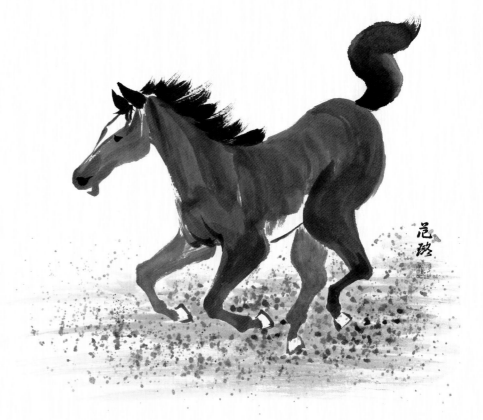

PENGUINS

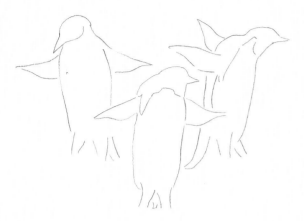

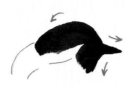

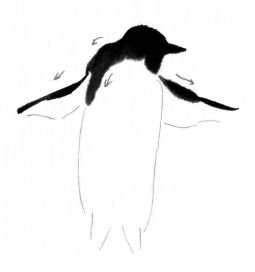

STEP 1

First determine the position and form of each penguin by creating a light sketch in pencil. Make sure that each penguin is slightly different from the others so the composition isn't too symmetrical.

STEP 2

Then paint the head of one penguin with a soft brush dipped in medium ink and tipped with dark ink. Start with a water-drop stroke from the forehead to the back of the head. Holding the brush vertically, paint the beak with the point of the brush and follow with a water-drop stroke down through the throat.

STEP 3

Now, still using the soft brush that has been dipped in medium ink and tipped with dark ink, apply a water-drop stroke from the base of the penguin's head over the shoulder and down the side of the body. With the same brush dipped in dark ink and held vertically, sweep from the shoulders to the tips of the wings.

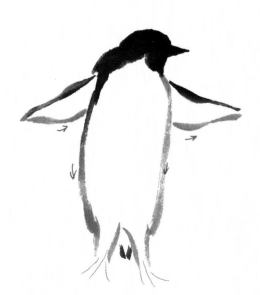

STEP 4

Next load a stiff brush with light ink, tip it with medium ink, and paint the outline of the body, legs, and tail with quick, brisk strokes.

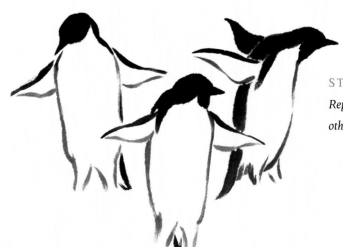

STEP 5

Repeat steps 2–4 for the other two penguins.

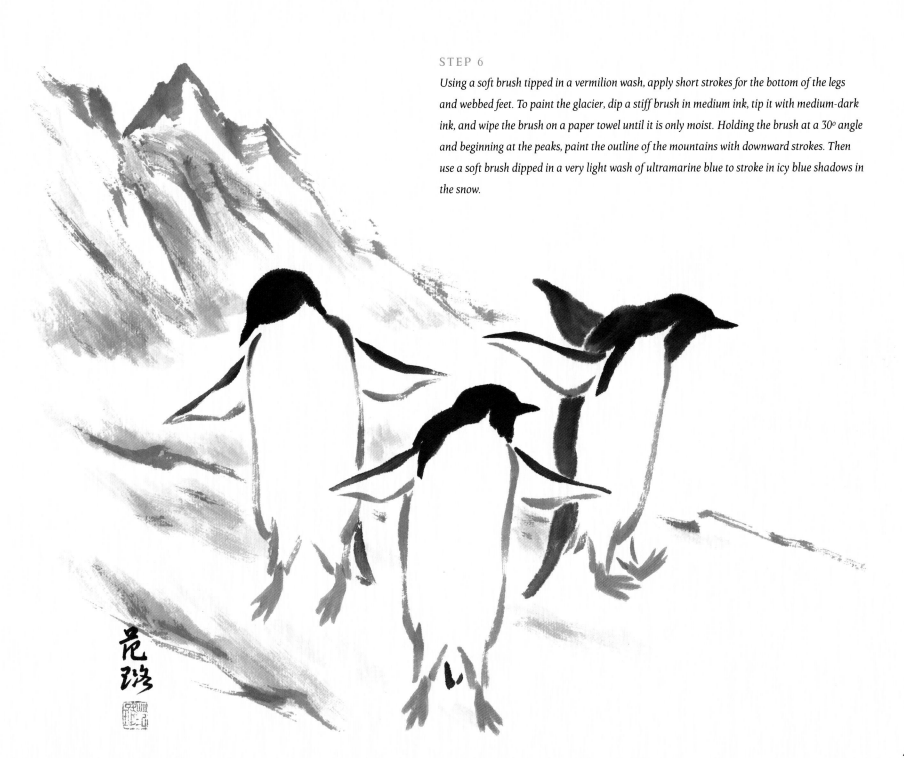

STEP 6

Using a soft brush tipped in a vermilion wash, apply short strokes for the bottom of the legs and webbed feet. To paint the glacier, dip a stiff brush in medium ink, tip it with medium-dark ink, and wipe the brush on a paper towel until it is only moist. Holding the brush at a 30° angle and beginning at the peaks, paint the outline of the mountains with downward strokes. Then use a soft brush dipped in a very light wash of ultramarine blue to stroke in icy blue shadows in the snow.

CALICO CAT

STEP 1

First sketch the outline of the cat. Then saturate a small stiff brush with a lemon yellow wash, blot it on a paper towel, and paint a dot for the eye with a small, rounded water-drop stroke. Using a soft brush tipped in dark ink, outline the eye with the brush point and add dots for the base of the whiskers. Tip the brush with medium ink and finish the outline of the cat's face and body with a series of bone strokes.

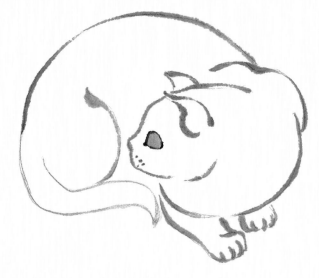

STEP 2

Saturate a soft brush with light ink tipped with dark ink and dry the brush slightly on a paper towel. Apply a water-drop stroke from the top of the head around the ears, leaving the ears unpainted. Continue to add markings along the top of the cat's back with water-drop strokes. Using the same brush dipped in light ink and tipped in dark ink, start at the tip of the tail and stroke in a curved line to meet the cat's rear marking. For the whiskers, use a dry stiff brush moistened with dark ink to paint several thin bone strokes from the side of the cat's mouth outward. Then add the dark spot for the nose and the short line indicating the mouth. Finally, using the same brush, paint a thin vertical line to indicate the cat's pupil.

STEP 3

Rinse the soft brush and load it with a light wash of burnt sienna tipped with darker burnt sienna. With water-drop strokes, paint reddish-brown markings on the cat's ears, face, and back.

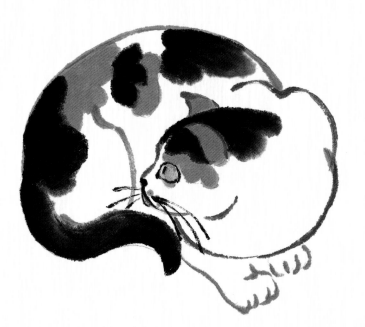

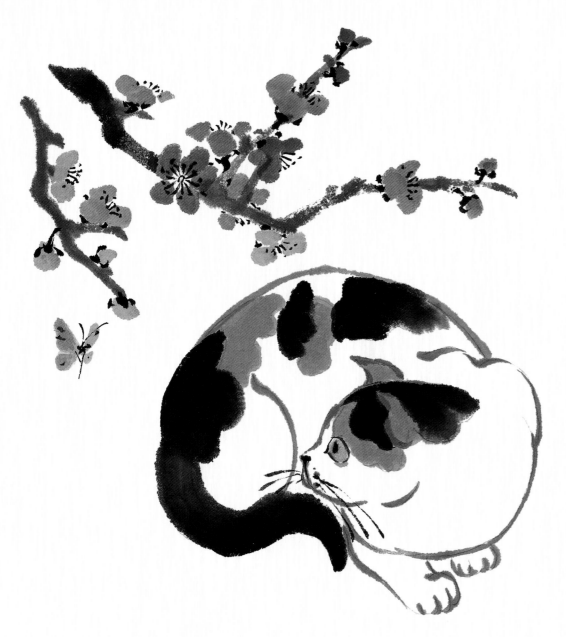

PAINTING THE FLOWERS AND THE BUTTERFLY

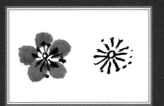

To create the blossom, dip a soft brush in a light crimson red wash, tip it with a darker crimson red, and paint five rounded water-drop strokes for the petals. For the flower's stamen, saturate a stiff brush with dark ink and blot it on a paper towel. Use only the tip of the brush to paint a small circle in the center and several lines radiating out.

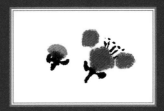

To paint the sepal—which can be seen only on buds and flower profiles—use dark ink to add a short stem and two small water-drop strokes at the base of the flower. The water-drop strokes should curve slightly and rest perpendicular to the stem. Use only three petals to show flowers from a side view. For each bud, simply paint one dot.

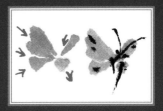

For the butterfly, soak a stiff brush in a wash of lemon yellow, tip it with burnt sienna, and paint four water-drop strokes as shown, making the top two sections of the wings longer than the bottom sections. For the butterfly's body, tip a stiff brush in dark ink and indicate the antennae, body, legs, and black markings on the wings.

STEP 4

Now add a colorful plum branch and butterfly (demonstrated in the box on the right) to complement this adorable cat. For the branches, load a stiff brush with light ink and tip it with dark ink. Holding the brush vertically, paint the branches with bone strokes.

TIGER

STEP 1

First lightly sketch the tiger with a pencil. Copy what you see, being careful to imitate the angle of the head, the folds in the skin, and the stripes on the face.

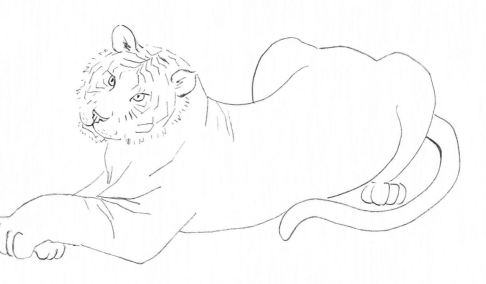

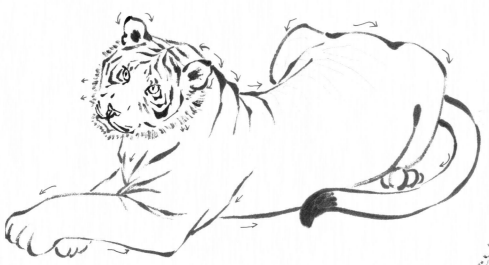

STEP 2

Now use the fine point of a dry soft brush and medium-dark ink to outline the entire tiger. Start with the eyes, and then paint the nose, mouth, ears, and body. Use more pressure for thick lines and lift the brush to taper the stroke for thin lines.

STEP 3

Use the same brush and dip it in medium-dark ink to paint stripes that curve down from the top of the back to the side of the body. Keep in mind that the markings do not necessarily connect from top to bottom; the stripes appear more realistic when broken up. For the tail, paint curved black stripes that continue to the solid, dark tip.

STEP 4

Next mix a light yellow wash with small amounts of burnt sienna and light black or ink. Use a soft brush to layer this color on the tiger's head and body. Begin from the top of the back and continue down the side of the body, but leave the stomach and the area around the eyes white. When the color dries, stroke burnt sienna over the face and the black stripes. The forehead, nose, cheeks, and top of the back should all be darker. (If the color bleeds into areas that are meant to be white, use white paint to cover the color.) Mix a thin wash of lemon yellow to fill in the eyes.

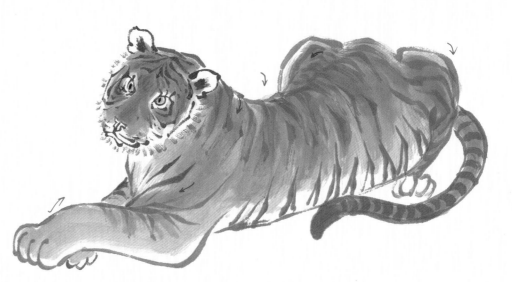

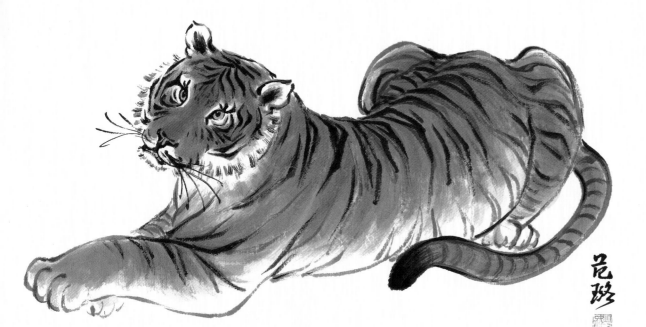

STEP 5

With a dry stiff brush saturated with dark ink, retrace the outline of the face and some of the stripes on the body to make them more distinct and to create variations in the stripes' values. It is not necessary to highlight every stripe; make the markings most intense on the back and keep the markings on the stomach medium gray. For the whiskers, use a dry stiff brush with black ink and begin painting from the black markings above the mouth. Be sure to use rapid strokes to create thin dry lines. To finish, dip the tip of a dry brush into dark ink to paint the pupils of the eyes. Then use thick white paint to add a light reflection in the upper edge of the pupils.

MONKEY

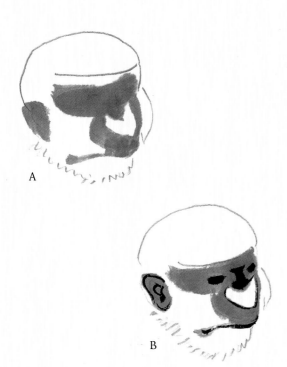

A

B

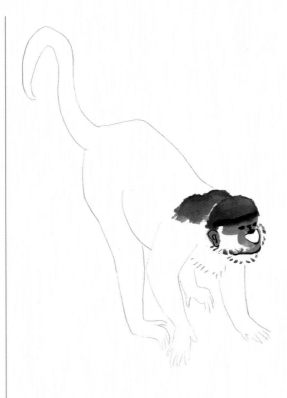

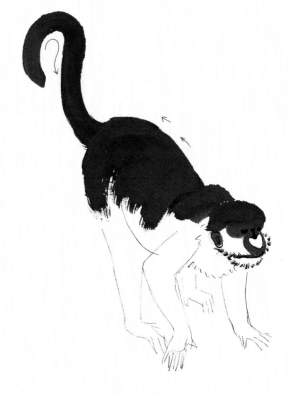

STEP 1

First draw the outline of the monkey in pencil. Mix a wash of ultramarine blue and paint a horizontal stroke across the monkey's forehead with a stiff brush; then trace around the heart-shaped nose (A). Next rinse out the brush and paint the eyes, ear, and outline of the nose with dark black ink (B).

STEP 2

Now load a soft brush with a wash of burnt sienna and light ink and tip it in black ink; brush on a semi-circle for the head and two water-drop strokes for the shoulders. Tip the brush again with dark ink and paint a horizontal line across the forehead for the hairline. Then load a stiff brush with a light wash of burnt sienna and black ink, blot the brush well on a paper towel, and add small swipes of the brush along the monkey's face to suggest wisps of hair.

STEP 3

Load a soft brush with a wash of burnt sienna and tip it with dark ink for the monkey's coat. Begin your first stroke at the lowest point of the back—between the shoulders—and sweep up and around the monkey's rear, keeping the darker tip of the brush along the pencil outline. Then paint several strokes from the monkey's back across and down the side of the body, lifting the brush after each stroke to create a coarse trail. Now dip the brush into the burnt sienna wash and tip it in a thicker wash of burnt sienna to add multiple shades of brown to the brush. Paint the tail in one long, continuous stroke from the tip of the tail to the monkey's rear.

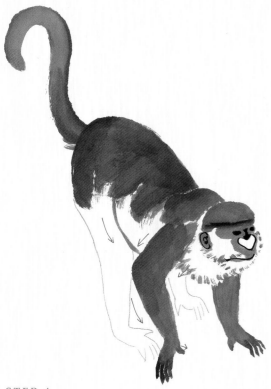

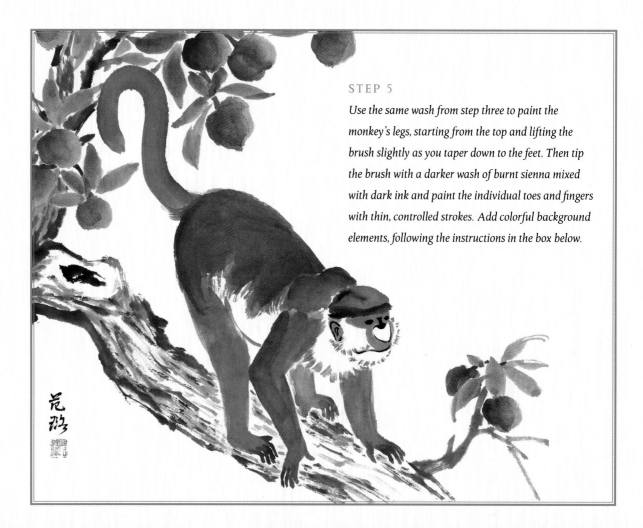

STEP 5

Use the same wash from step three to paint the monkey's legs, starting from the top and lifting the brush slightly as you taper down to the feet. Then tip the brush with a darker wash of burnt sienna mixed with dark ink and paint the individual toes and fingers with thin, controlled strokes. Add colorful background elements, following the instructions in the box below.

STEP 4

Saturate a soft brush with burnt sienna mixed with light ink. Tip the brush in dark ink and paint water-drop strokes from the shoulder to the hand. Then use the tip of the brush to paint a thin, curved line along the outline of the stomach.

PAINTING PEACHES

Using a thin mix of yellow and green tipped with crimson red, paint two water-drop strokes beside one another to make each peach. Then use a mix of yellow and green tipped with blue to create the leaves with small water-drop strokes.

PAINTING A TREE BRANCH

For the branch, load a stiff brush with medium-light ink and paint the outline of the branch. Fill in the branch with several light strokes, reserving the lightest strokes for the center.

ELEPHANT

STEP 1

After lightly outlining the elephant in pencil, load a soft brush with a thin mix of burnt sienna and a bit of black ink. Tip it with medium-dark ink and, holding the brush vertically, make a fluid, sweeping stroke from the tip of the trunk to the forehead.

STEP 2

Now paint a large water-drop stroke from the elephant's mouth to the chin, finishing the head.

STEP 3

Next tip the brush with medium-dark ink and paint a heart shape for the right ear, holding the brush at a 45° angle. Tip the brush with a wash of burnt sienna and paint the left ear with one stroke, leaving a small white space between the ears and the head.

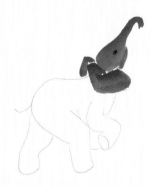

STEP 4

Now load a stiff brush with dark ink and paint the eye with a small water-drop stroke. Add two small moon-shaped marks for the eyelids.

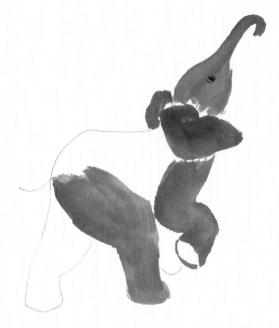

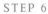

STEP 5

Saturate a soft brush with burnt sienna and tip it with medium-dark ink. Paint the right front leg from the top of the leg to the base, using a few strokes to copy the shape. Then paint the back leg, beginning from the top of the leg and stroking down to the bottom. Again you will need to use more than one brushstroke to fill this area, so be sure to apply each new stroke while the previous one is still wet. Otherwise the edges will dry, creating streaks within the painted areas.

STEP 6

Using a soft brush saturated with burnt sienna and tipped with medium-dark ink, paint several large water-drop strokes, swooping from the neck and curving over the elephant's backside. Add one stroke from the elephant's back curving down to the underside, but be sure to leave a gap of white between the legs and the stomach. Then use a dry stiff brush tipped with dark black ink to paint the tail with a long, thin, continuous stroke.

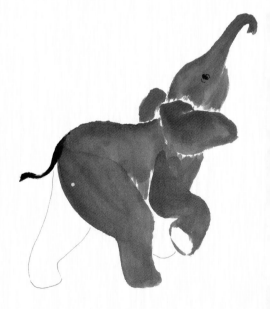

STEP 7

Using a soft brush dipped in thinned burnt sienna and a small amount of light ink, stroke from the top of the elephant's left leg to the bottom of the foot with a slight water-drop motion. Then paint the right front leg with one small water-drop stroke. For the elephant's toenails, tip the brush with medium-dark ink and paint a few dots along the bottoms of the feet. Load the tip of a stiff brush with a very light wash of thinned ultramarine blue and paint small droplets of water, starting at the tip of the trunk. For the mountain, load a soft brush with a light ultramarine blue wash and tip it with medium blue. Place the brush bristles onto the paper so that the tip is away from you and the bristles are lying flat against the paper. The handle should be leaning toward your face. Then pull the brush to the left and slightly toward you while slowly lifting the brush back to the vertical position. Using a stiff brush loaded with a wash of burnt sienna and black ink, paint thin bone strokes for the surface of the ground. Then use a mix of lemon yellow and deep green tipped with pure deep green to fill in the area below this line. Finally add the trees and flowers as shown in the box to the right.

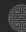

PAINTING THE TREES

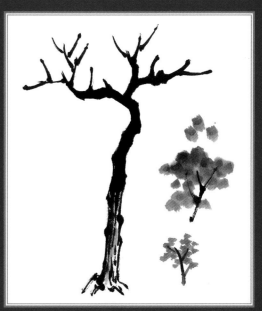

Saturate a dry stiff brush with a medium value of black ink and tip it with a dark value of black ink. Then paint the tree trunk and branches using bone strokes. To create the illusion of a round trunk with dimension, use a lighter value of ink in the center of the brush and a darker value in the outer bristles.

For the green leaves, load a small stiff brush with a mixture of lemon yellow and deep green, and then tip it with ultramarine blue. Next flatten the brush tip on the side of a dish or mixing palette. Hold the brush at an 80° angle, and paint small clusters of leaves by dotting the brush on the paper. Overlap the dots to create depth and texture. Paint the red leaves the same way you painted the green leaves, but use vermilion tipped with crimson red.

IRIS AND HUMMINGBIRD

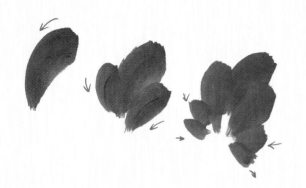

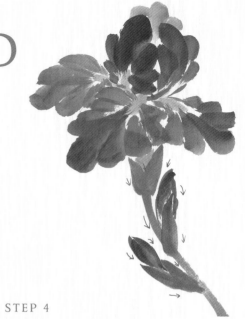

STEP 1

After sketching the whole scene in pencil, prepare a violet wash using a mix of cobalt blue and crimson red. Load a soft brush with the mixture and then dip it in pure water, creating a medium violet wash within the brush. Tip the brush with the initial violet wash, hold the brush at a 65° angle, and paint the first petal from top to bottom with a long, curved water-drop stroke. To modify the size and shape of the petal, add water-drop strokes to either side of the initial stroke.

STEP 2

Using the same strokes that were used in step 1 and following the arrows in the example, paint a second petal to the right of the first. For the third petal (at the top), tip the brush with a bit of water before applying the color. (Remember that each petal grows from the center point.) For the fourth petal (at the bottom), use a series of water-drop strokes to create the shape, gradually making each stroke shorter.

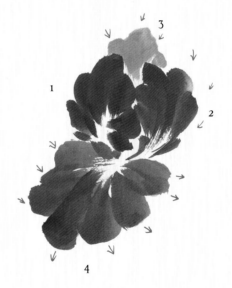

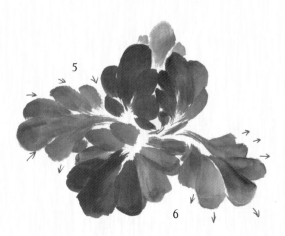

STEP 3

Tip the brush with cobalt blue to paint the fifth petal (on the top left). Then tip the brush with violet to alter the color for the sixth petal (on the bottom left). This variation in color within the flower will give the blossom a sense of depth and keep it from appearing flat on the paper.

STEP 4

Mix a lemon yellow and deep green wash with a large stiff brush and tip it with crimson red. Paint the sepals from the base of the flower outward with water-drop strokes; then paint the stems with long, thin bone strokes. Load a soft brush with a violet wash to add a round bud, placing a bit of lemon yellow wash in the center of the flower petals for the stamen.

STEP 5

Tip a stiff brush in dark ink and blot it on a paper towel. Then hold the brush at a 65° angle and paint a water-drop stroke from the tip of the bird's beak toward the face, adding more pressure to the brush at the end of the stroke. Use the same brush to paint two small dots for the eye, leaving a white space for the highlight. Finally paint the wispy black feathers around the eye with short, quick strokes

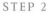

STEP 6

Load a small soft brush with a blue-green wash of viridian green and cobalt blue. Tip the brush with a pure cobalt blue wash and paint the top of the head with a water-drop stroke, starting from the beak. Add two smaller water-drop strokes to form the back of the neck. Then paint several water-drop strokes for the base of the wings, dipping again in the light blue-green and tipping in cobalt blue.

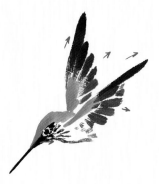

STEP 7

Now load a stiff brush with medium ink and flatten the tip by running the brush along the edge of a dish or palette well. Starting from the end of the beak, paint outward strokes to create a triangular throat. Use the same brush to outline the stomach. Then dip a stiff brush into medium ink and tip it with dark ink to paint feathers on the wings using long water-drop strokes, pressing down at the end of each stroke.

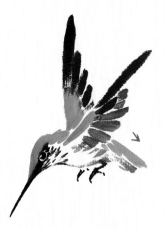

STEP 8

Next load a soft brush with a light blue-green wash and paint water-drop strokes within the tail. Then, without rinsing the brush, tip the brush in light ink and fill in the layer beneath the tail with gray strokes. Now tip a stiff brush in dark ink and paint the bird's feet with small bone strokes.

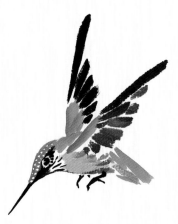

STEP 9

Mix a thick wash of white paint and use a stiff brush to paint rows of dots on the bird's head. Then apply a thin layer of cobalt blue on the top of the head. Now use a soft brush tipped with burnt sienna to add a light brown to the bird's underside.

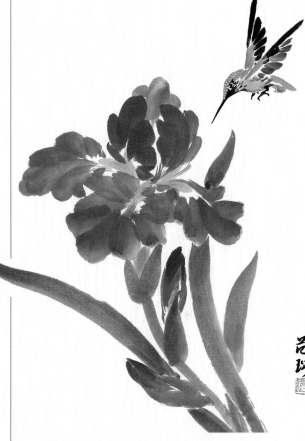

STEP 10

To create the leaves, mix a wash of lemon yellow and deep green with a large stiff brush and tip it with ultramarine blue. Paint each leaf from top to bottom, lifting the brush as you stroke down. Then tip the brush with a crimson red wash and add the leaf in the background.

FEMALE FIGURE

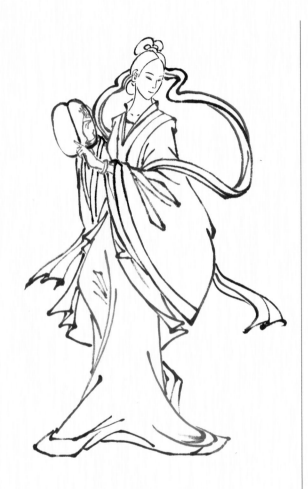

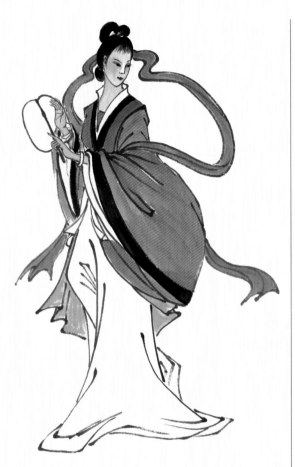

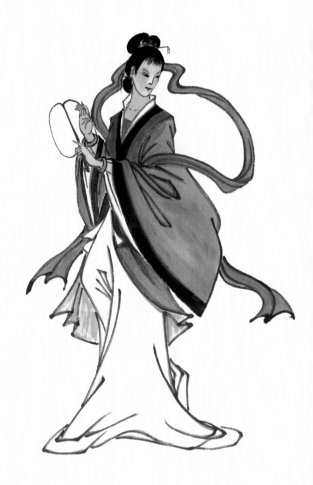

STEP 1

Begin by sketching the outline of the figure on paper. Next use a very small brush dipped in medium ink to retrace the image with long bone strokes, blotting the brush on a paper towel to create a coarse, controlled line. (If you wish to trace the exact figure from this project, you can make an enlarged photocopy of step one and place rice paper on top for tracing.)

STEP 2

Paint the head as demonstrated in the box on page 55; then fill in the hands with the same light vermilion wash used on the face. Load a large soft brush with a cadmium red wash and apply color generously within the outline of the robe. Then, using a small soft brush, paint the edge of the robe with black ink and paint the ribbon with a cobalt blue wash.

STEP 3

Next go over the outline of the robe again with a very small brush dipped in dark crimson red. Apply a wash of light burnt sienna over the folds of the skirt with a soft brush. To create the skirt cover, use a soft brush dipped in a dark wash of cobalt blue. Now paint on the woman's bracelet with a light blue-green wash and a very small brush; then add the hair ornaments using cobalt blue, light blue-green, and cadmium red.

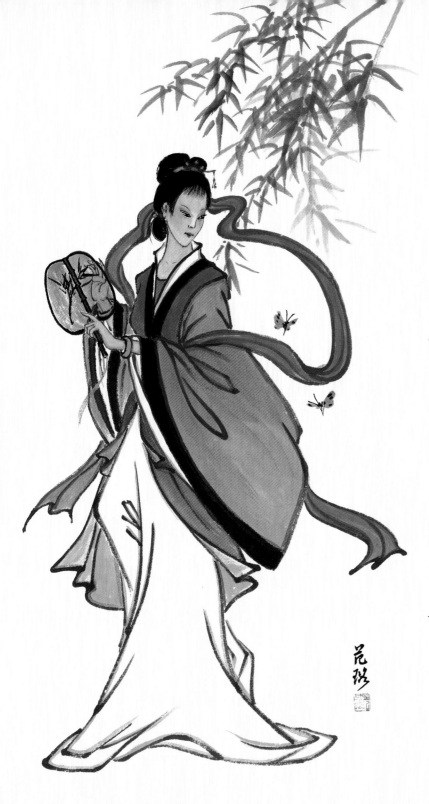

STEP 4

Fill in the fan using a small soft brush dipped in light ink. After the ink dries, tip the brush in dark ink to create the frame of the fan and to paint the small bamboo design. Next add the cluster of bamboo leaves above the figure using the tip of a small stiff brush dipped in a yellow and deep green wash and tipped with ultramarine blue. Paint each leaf with a long, thin water-drop stroke that tapers to a fine point, making some of the leaves cross and overlap. To add the two butterflies, follow the instructions on page 26.

PAINTING THE HEAD

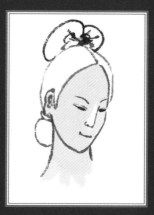

Create a light vermilion wash to produce a pale peach color. Saturate a small soft brush with the peach wash, and fill in the woman's face and neck. Leave the nose unpainted to suggest a highlight.

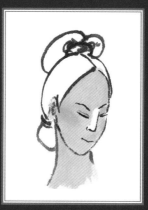

After the face dries completely, load the same brush with a light crimson red wash and blot it on a paper towel to dry it slightly. Then stroke the brush lightly over the upper cheeks, giving the woman a blushed appearance.

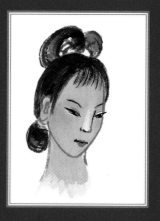

Next paint the eyes with a very small, dry brush and thick, dark ink. Then, using thick white paint and the tip of a brush, dot highlights on each eye. Paint the hair with short strokes of dark ink and the flattened tip of a small soft brush.

CHICKS AND TRUMPET VINE

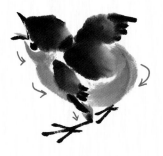
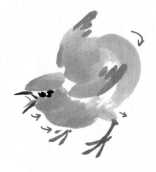

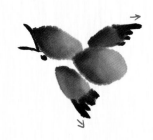
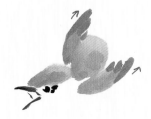

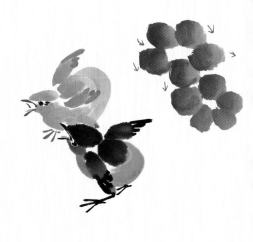

STEP 1

After marking the position of each element of the painting in pencil, begin painting the chicks. Load a soft brush with light black ink and tip it with dark ink. Holding the brush at a 65° angle, paint four fat, egg-shaped water-drop strokes for the head, back, and wings. (For the yellow chick, repeat this process using a lemon yellow wash tipped with burnt sienna.)

STEP 2

Dip a very small brush in dark ink, blot the bristles on a paper towel, and hold the brush at a 65° angle to paint the beak and eye. Then use a small stiff brush tipped in dark ink to paint four water-drop strokes along the tip of each wing. The largest stroke should be the farthest from the body. (For the yellow chick, use burnt sienna tipped with medium ink to paint the beak and burnt sienna to paint the tips of the wings.)

STEP 3

Saturate a large soft brush with light ink tipped with medium ink and paint one water-drop stroke from the corner of the beak around the bottom of the eye. Apply another water-drop stroke for the chick's chest. (For the yellow chick, use lemon yellow tipped with burnt sienna.) To paint the legs and feet, use a very small brush tipped in dark ink and bone strokes. (For the yellow chick, use burnt sienna tipped in light ink.) Finally add a small stroke of a vermilion wash for the tongue.

STEP 4

Now that the chicks are complete, begin painting the flowers. Use a large soft brush loaded with vermilion and tipped with crimson red to paint the petals with round water-drop strokes, giving each flower five petals and leaving the center unpainted. To make each stroke, flatten the bristles, hold the brush at a 65° angle, and paint downward.

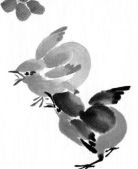

STEP 5

Without rinsing the soft brush, tip it with lemon yellow and paint the cone-shaped bulbs at the base of each slight- or full-profile flower using several side-by-side strokes. Then soak the brush with a vermilion wash and tip it with lemon yellow to paint the buds with small water-drop strokes.

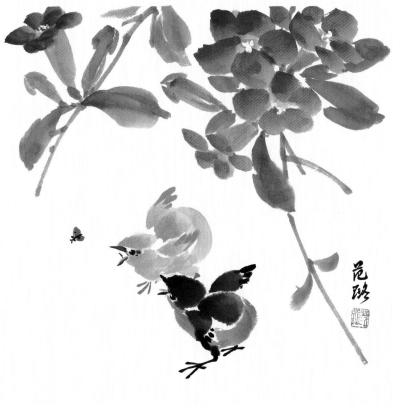

STEP 6

Next use a large stiff brush dipped in light ultramarine blue and tipped with darker blue to paint the leaves with water-drop strokes. You may want to add multiple strokes to achieve the desired shape.

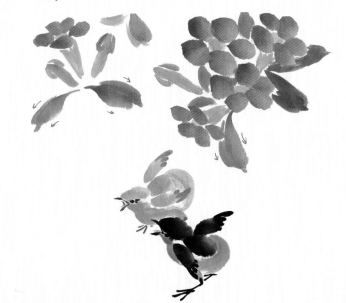

STEP 7

Load a very small brush with a wash of lemon yellow and ultramarine blue. Holding the brush upright, paint branches with bone strokes and connect the flowers to the leaves with short strokes. Add a long vine sweeping down from the main cluster of flowers and curving to the right; you may want to add more blue leaves growing on the vine. Then paint the ladybug as shown in the box below.

PAINTING THE LADYBUG

Saturate a very small brush with cadmium red and tip it with crimson red. Paint two small water-drop strokes for the wings. Rinse out the brush. Tip the brush with dark ink, and paint one small stroke between the wings for the body. Then add dots for the eyes, antennae, and spots.

LANDSCAPE

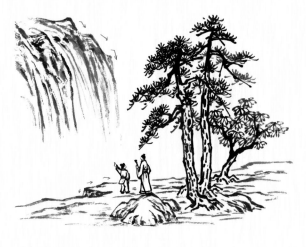

STEP 1

First lightly sketch the scene on paper with a pencil. When there are several elements in a composition—such as a landscape with trees, mountains, sky, and figures—it is important to mark the position of each element before applying ink so you can make proportion adjustments.

STEP 2

Next use a small stiff brush dipped in light ink and tipped with dark ink to paint the tree trunk with downward bone strokes. Holding the brush straight up and down, paint the branches with smaller bone strokes. Then add texture to the trunk by filling in the spaces with short bone strokes. Next paint two more trees in the same manner, and add the foliage as shown in the box below. Then, using a very small brush dipped in dark ink, outline the figures in your scene.

STEP 3

Paint the outline of the rock as demonstrated in the first step on page 59. Then load a stiff brush with medium ink, tip it with dark ink, and dry the brush slightly on a paper towel to remove some moisture. Apply a series of horizontal strokes to suggest the ground. To give your landscape a sense of space and depth, add the distant mountains and the ground. Reload the stiff brush as described above and trace over the nearest mountain outline; then, holding the brush at a 30° angle, suggest streams of water by sweeping a series of lines from the top of the waterfall to the bottom.

PAINTING THE NEEDLES AND LEAVES

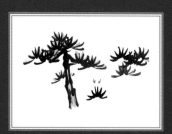

Load a small stiff brush with medium ink and tip it with dark ink. Holding the brush upright, paint the pine needles with downward strokes. Arrange the needles in bundles, allowing some needles to overlap each other.

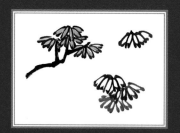

For the tree on the far right, use a small stiff brush dipped in medium ink and tipped with dark ink. Paint two lines for each downward-turning leaf, holding the brush upright.

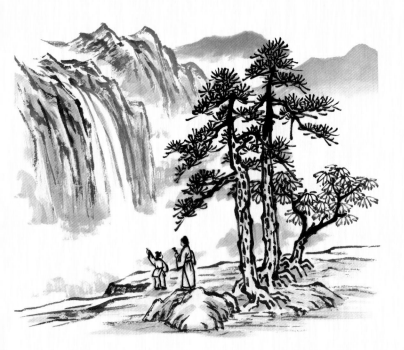

STEP 4

Add the far mountain by retracing the sketch with the stiff brush dipped in medium ink and tipped with dark ink. Now apply a layer of shading to the ground and various planes of the mountains with a light ink wash. To add the colorful hazy mountains in the distance, load a large soft brush with a light burnt sienna wash for the mountain on the right. Hold the brush at a 30° angle and move it from right to left repeatedly to create different shades within the strokes. Paint the blue mountain in the same manner but using a light ultramarine blue wash.

PAINTING THE ROCKS

Using a large stiff brush dipped in light ink and tipped with dark ink, paint the outline of the rock. Add shading with a small soft brush dipped in light ink.

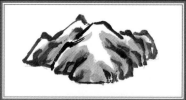

Then use a small soft brush dipped in burnt sienna and tipped with light burnt sienna to paint the lower part of the rock around the base, as shown.

STEP 5

Next apply the first layers of color to the other elements in your landscape. Using a soft brush dipped in burnt sienna and tipped with light burnt sienna, stroke the wash on the lower areas of the rock, the mountain, the ground, and the tree trunks. Be sure to leave the waterfall area unpainted. Now use a small stiff brush to add color to the leaves and the needles of the trees with a light blue-green wash (for example, viridian green mixed with cobalt blue). To add color to the waterfall, mix a light blue wash and paint over the water with a soft brush.

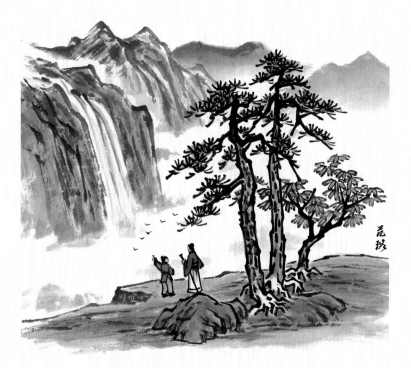

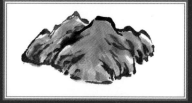

To give the rock a cool, stonelike hue, apply a thin wash of indigo blue down the center of the rock. Then add a light blue-green wash to the top surface of the rock.

生意興隆　日日旺　財源廣進　年年滿

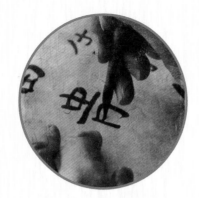

CHINESE CALLIGRAPHY

Chinese calligraphy, or "shu fa," has been highly revered, respected, and loved throughout China's long and proud history. Simply

put, calligraphy is a group of characters written with a brush and black ink on a piece of paper; yet the style, shape, and movement of

good Chinese calligraphy has an aesthetic significance that matches the importance of art in the East and the West.

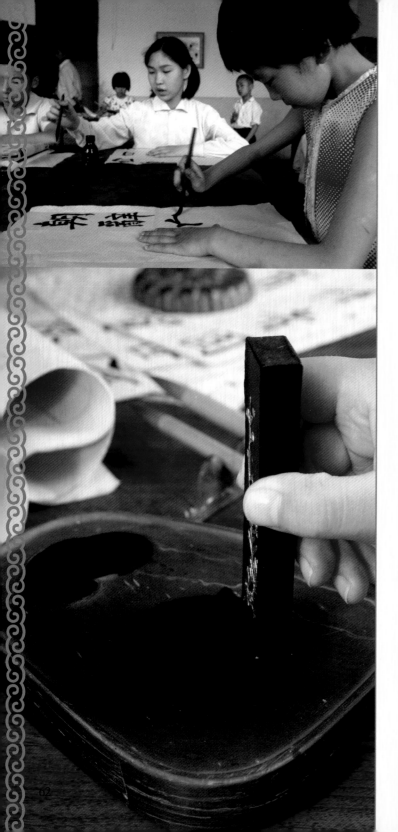

Calligraphy is a unique art, closely linked with the lives of Chinese people and far-reaching in its striving for perfection. In this section you will learn the techniques of Chinese calligraphy, including gathering together the necessary tools and materials and learning, step by step, how to make the strokes you will need to construct your characters.

The influence of Chinese calligraphy on cultural life in China is much greater than that of Western calligraphy on the Western world. Children are taught from a young age to love and respect calligraphy—and many grow up hoping to become calligraphers. Schools hold at least one calligraphy lesson a week. Whether it is the tools, the Chinese characters, or the brushstrokes, the spirit this art instills transcends all explanation and resonates among its practitioners from their earliest experiences of it, prompting many to revisit it in later life.

The art of calligraphy is widely popular not just in China, but also in Japan and Korea, where it is promoted and revered as the ultimate scholarly pursuit. The atmosphere is intense, moving, and reverent. It is an art to become totally absorbed in.

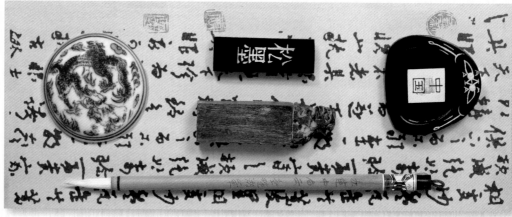

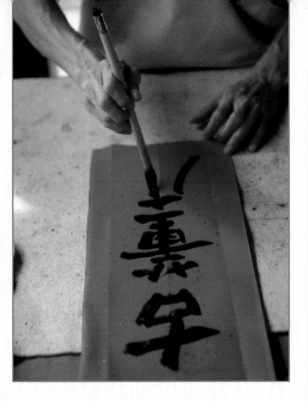

At the heart of calligraphy is the brushstroke. Calligraphy's beauty, strength, and spirit can be traced along the lines that the brush produces with the help of paper, ink, and ink stone. There is no question that they work in perfect partnership.

The following pages will take you through the basic tools and equipment you will need before you begin practicing. This is followed by step-by-step guides to each of the main techniques required to form strokes. Read through this section before starting any of the characters, and refer back to it once you've begun writing characters.

APPRECIATING CHINESE CALLIGRAPHY

Chinese calligraphy is art; so let us regard it as we would any painting. Below are the criteria essential in appreciating a piece of calligraphy.

STROKES

Are the strokes alive as if they are moving on the paper? Are they executed with variations of thickness and style? Can you see the intrinsic energy ("gu qi") present within the strokes? If you don't detect any of these, the strokes would look lifeless and flat.

THE SOUL, OR "QI"

Chinese calligraphy is the combination of technique and the calligrapher's personal emotional expression. When a calligrapher reaches a certain level, the spontaneity and emotions are woven into the lines. This creates a flowing vibration and energy ("qi") right through to the end. These two characters by Kwan Shut Wong illustrate this beautifully.

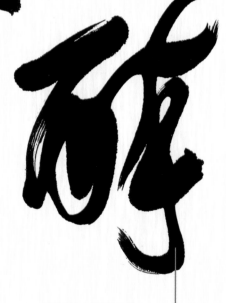

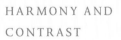

HARMONY AND CONTRAST

This variation exists in any art form. We should expect to find harmony and contrast both within any character and in the whole piece of calligraphy.

CHARACTERS

Do they look well balanced, beautiful in shape, and flamboyant in style? Are they written with a sense of continuity, in such a way that they seem to relate to the adjacent characters?

TOOLS AND MATERIALS

PAPER ("ZHI")

Paper is one of the greatest inventions of the Chinese people. Until recently, Cai Lun (East Han dynasty, AD 25–221) was credited with its discovery. However, fresh excavations have uncovered paper scrolls dating to the West Han dynasty (202 BCE), much earlier than previously recorded.

"Xuan" paper is the predominant type of paper used for modern calligraphy and Chinese painting. This white paper is composed primarily of green sandalwood, straw, bamboo, and bark, giving it a toughness that belies its thin, soft, and absorbent texture.

THE THREE MAIN TYPES OF XUAN PAPER

Raw Xuan—Most suitable for painting, this paper is the most absorbent of the three. It is not cut to size.

Shu Xuan—This paper is more suitable for calligraphy as it has a lesser degree of absorbency and has been sized with alum.

Semi-raw Xuan—This paper has also been sized with alum, but remains absorbent.

PAPERS YOU CAN GET FROM SUPPLIERS

You can buy Xuan paper, grass paper (Yu Kou Zhi), Moon Palace paper, and red paper (for special occasions) from most art shops. The paper you buy is not prepared to standard sizes, so it is usually necessary to cut it yourself.

PRACTICE PAPER

You can use anything that you think is suitable for practice and rough work—from newspapers to wallpaper!

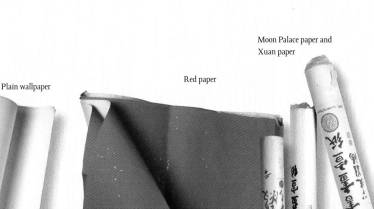

Cactus paper

Grass paper

Plain wallpaper

Red paper

Moon Palace paper and Xuan paper

MOUNTING

This is an important step in the presentation of calligraphy. Mounting gives the finished piece a smooth and bright look, while enhancing the color. However, the procedure can be laborious, so it's best to mount a few pieces at once to save time.

STEP 1

Mix some wallpaper paste with water—add more water than instructed on the packet because calligraphy paper is thinner than wallpaper. Test the consistency on a scrap of calligraphy paper before using on your final piece. Use a pencil to mark where you want your border to be.

STEP 2

Lay the calligraphy face down on the table. Spray it with just enough water to stop it from moving. Apply the paste to the back of the piece with a wide brush, working from the center outward. Don't forget the corners.

STEP 3

Lay the second, larger piece of paper on the back of the calligraphy, making sure it is spaced four inches from the top. Brush down with a clean brush to remove any bubbles. Use a dry brush to continue smoothing.

STEP 4

Apply paste to the border, then carefully lift the piece up, using a rod if it is a long piece, and stick it onto a board with the calligraphy facing outward. When it is dry (this takes a few days), remove the calligraphy from the board by cutting the edges. The mounted piece will be smoothly stretched and ready to be framed.

BRUSHES

The Chinese have been using these tools for over 4,000 years. The most famous Chinese brushes are made in Hu Zhou in the province of Zhe Jiang. Brushes are traditionally made of animal hair stuffed in a bamboo tube, with each type of hair providing the bristle with a unique texture and stroke. The best brushes for calligraphy beginners are those made of wolf hair, or those made of weasel, rabbit, or mixed hair. Always check the fullness, resilience, and evenness of a brush before purchasing.

The writing on a brush's handle describes the type of hair the brush is made of.

1 BEAR-HAIR BRUSH
The hair of bears is very strong, creating a hard-wearing, and resilient brush.

2 DEER AND WOLF MIXED-HAIR BRUSH
Deer hair is soft and absorbent. This brush offers the benefit of both types of animal hair.

3 LARGE GOAT-HAIR BRUSH
Goat's hair is soft and absorbent, so it is easy to manipulate between strokes.

4 LARGE HORSE-HAIR BRUSH
This thin-handled brush uses lots of ink. You will need a large ink stone/pot to hold enough ink for just one stroke.

5 GOATS'-BEARD-HAIR BRUSH
Made of mountain goat hair, this brush is stiff with tremendous energy. It is fantastic for painting.

6 GOAT-HAIR BRUSH
This Hu Zhou soft-haired brush retains more liquid than the hard-haired brushes. It is suitable for both painting and calligraphy.

7 ORCHID AND BAMBOO BRUSH
This brush is both resilient and springy. It can be used for both painting and calligraphy.

8 LARGE MIXED-HAIR BRUSH
Full, pointed, even, and resilient, this tool has all the qualities of a good brush.

9 PURPLE-HAIR BRUSH
This Hu Zhou brush is made from wild rabbit hair.

10 WOLF-HAIR BRUSH
Calligraphers favor this brush because it is strong and full, as well as flexible—useful when negotiating within lines.

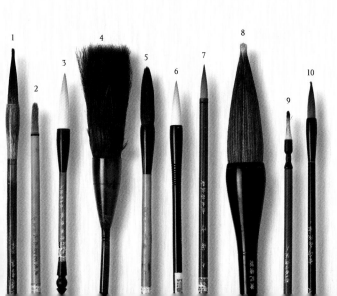

HOW TO CARE FOR BRUSHES

NEW BRUSHES
Remove and discard the lid. Soak in warm water for at least 20 minutes (depending on brush size), until the glue coating the hair has dissolved. Use your fingers to reshape the brush into a point and remove any excess water.

CLEANING BRUSHES
Have a pot of water ready for rinsing. Always clean your brush when you finish writing or when taking a break. More thorough cleaning should be done under a tap, as calligraphy brushes take up lots of ink.

HOW TO CHOOSE BRUSHES

The famous Hu Zhou brush makers assert that a good-quality brush is pointed, even, full, and resilient.

POINTED
The tip of the brush should be pointed and centered.

EVEN
When you flatten the tip of the brush with your fingers, the hairs should all be the same length.

FULL
The brush should be substantial, well rounded, and symmetrical, with tightly packed hairs.

RESILIENT
A good brush should be strong, healthy, and durable. Its hair should spring back into place when bent—if a brush remains bent after a stroke, it is too soft.

INK ("MO")

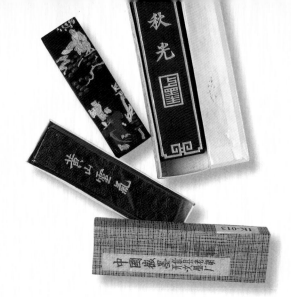

Chinese ink is made by mixing the soot collected from burnt pine or oil with glue (traditionally made from deer horn or animal hides). Top-quality ink sticks have a clear, crisp sound when tapped with your fingers and should be hard and heavy, with a purple sheen. The lighter the sheen, the poorer the quality of the ink. Good ink retains its color for a very long time and will not spread, even after mounting.

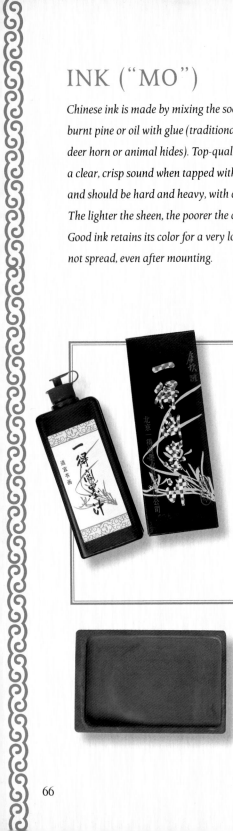

TYPES OF INK

Pine oil ink stick*—This ink is made by adding glue to the soot of burnt pine branches.*

Oil ink stick*—A rich black ink made by burning sesame oil over an oil lamp, then adding glue. As a higher ratio of glue is used than in any other ink, lots of water must be used during grinding.*

Pine lampblack ink stick*—Made by burning cooking oil and pine branches over an oil lamp, then adding glue. The rich, black color has an extra sheen that makes it suitable for calligraphy.*

Bottled ink*—There are several manufactured bottled inks on the market. Use these to practice with.*

INK STONE ("YAN")

An ink stone is used for grinding ink. It can be made of stone or clay. You need an ink stone with a smooth surface that will not damage your ink stick. It must also be big enough to hold the amount of ink you need for calligraphy. The most famous ink stones are "Duan yan" and "She yan."

MAKING INK

Ink grinding can be the perfect time to contemplate the piece of writing you are about to begin. Follow the steps laid out here to learn how to prepare your ink.

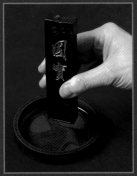

STEP 1

Drip some water (not too much at first) onto the ink stone. Hold the ink stick upright and use a moderate movement to grind steadily and evenly in one direction. Try not to press too hard on the stone so as not to damage the stone's surface.

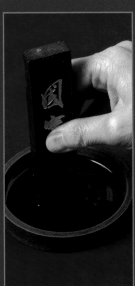

STEP 2

The ink will thicken slightly when it is ready. You can test it on the paper to check the consistency. A good consistency will allow you to lift the brush off the paper without dragging on it. If the ink is too thick, drip in some more water and grind again. When you are finished using the ink stone, use tissues to wipe off the ink. Rinse it under the tap to remove any excess ink, then dry it.

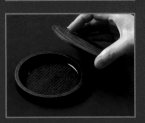

STEP 3

Pour a little clean water onto the ink stone and put the lid on, ready for next time.

TOOLS FOR PAPER

BLANKET

Use to cover your work table.

PAPERWEIGHT

Essential when working with Chinese paper, which has a tendency to roll up. Try making one yourself, using pebbles, a long piece of wood, or a decorative pottery slab.

TOOLS FOR BRUSHES

BAMBOO MAT

For storing brushes when traveling to prevent the tips from getting damaged. You can buy these in any good Chinese supermarket.

BRUSH STAND

Hang brushes on this tip down to dry after cleaning (best practice).

BRUSH POT

For storing dry brushes with their tips upward.

BRUSH REST

Use when taking a break from writing to keep brushes from rolling about. They are usually made of metal or ceramic. If you can't find one, a chopstick rest does the trick.

BRUSH WASH

Any glass container filled with clean water. For your own convenience, always have one ready when writing.

WATER CONTAINER WITH A SPOUT

Used to drip water into ink when mixing, or when ink dries out.

TISSUE PAPER

Always have a roll of tissue ready for cleaning purposes.

Paperweights

Brush Stand

Brush Rest

Brush Pot

Water Containers

NAME SEALS

Consider creating a seal to stamp your work with. A good calligrapher is always accompanied by his/her cinnabar paste and personalized name seal.

SEAL ("YIN ZHANG")

Artists devote a lifetime to the exquisite art of seal making. Seals can be square, round, oblong, or irregular in shape. Soapstone is preferred for seal making, as its softness makes it easy to engrave.

There are two types of seals: name seals and leisure seals. Name seals are used as a form of personal identification on documents, calligraphy, or paintings to declare either ownership or authorship. An artist's name seal is normally stamped below his/her name on a scroll. A leisure seal is a fun seal. Anything that is dear to you can be engraved on it, such as a short phrase (e.g., "entwined with the ink" or "the talents that God endowed me with must be useful") or a meaningful image (e.g., a dragon or Buddha). The characters that make up the phrases are engraved on the seal in Xiao Zhuan (Small Seal Script).

SEAL PAD ("YIN NI")

The red cinnabar paste used to stamp a seal is a delightful contrast to the black-and-white austerity of calligraphy—the two complement each other perfectly.

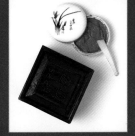

There are different sizes to choose from— you need a big pot of cinnabar paste to accommodate the larger seals.

Always keep the lid on the cinnabar to prevent it from drying out.

HANDLING THE BRUSH

The brush is an extension of the calligrapher's hand. Therefore, it is important that you are comfortable and at ease with it. Keep the brush upright most of the time, making sure you are deliberate but flexible in its use. The rounded handle will allow you to turn it when needed. Hold the brush with your fingers only, remembering to leave an empty space between it and your palm. Hold the brush higher when writing big characters and lower for the smaller ones, but never close to the bristle. If you practice every day, any discomfort you may feel in holding the brush will disappear.

HOLDING A BRUSH

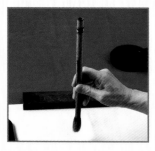

STEP 1
Hold the brush primarily with your thumb and first two fingers, followed by your ring finger. Use your little finger to push it from behind. Keep a gap between your palm and the brush.

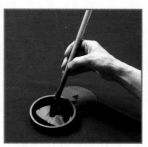

STEP 2
Tilt the brush and dip it in the ink, rotating it until the bristles are completely saturated.

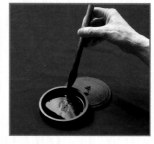

STEP 3
Use the edge of the ink stone to scrape off the excess ink. Keep rotating the brush until the tip is pointed and centered.

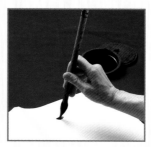

STEP 4
Hold the brush upright above the paper, ready to place the tip for the first stroke.

THE DIFFERENT WAYS TO HOLD A BRUSH

FOR SMALL CHARACTERS
Use a smaller brush when writing small characters. Hold the brush about one inch from the bristle (no lower). If you wish, you can keep your elbow on the table to steady you, but keep your wrist elevated so that you can move your hand freely.

FOR MEDIUM-SIZED CHARACTERS
Adopt whatever position is comfortable for you—sitting or standing. You may find that standing gives you more freedom of movement. If you opt to sit, practice elevating your elbow off the table while lowering your shoulders—the standing stance breathing exercise is helpful in creating this position, as it relaxes your shoulders and elbows.

FOR BIG CHARACTERS
Big characters require great flexibility of movement, so it is easiest to stand in front of your work. It is best to work on a long table so that you can pull the paper back out of your way while writing. Hold the brush further up the handle until you are confident in controlling the brush. Leave a bigger space between your palm and the brush to allow for more freedom and flexibility. Keep your brush pointed straight down while lowering your shoulders and relaxing your elbow.

BASIC STROKES

WRITING TECHNIQUES

Technique is of the utmost importance in Chinese calligraphy. Each time the calligrapher touches brush to paper, the thousands of hairs in the bristle tell the calligrapher whether the strokes should dance, twist, pull, drill swiftly, heavily, lightly, or contemplatively.

The basic techniques in brush-handling are "ti" (lift) and "dun" (press downward). Ti and dun command the control of all movement in the art of calligraphy.

The only way to tackle and master these techniques is to practice—try practicing on newsprint, or rolls of cheap, plain wallpaper.

TI (LIFT)

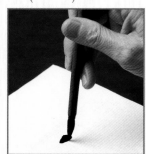 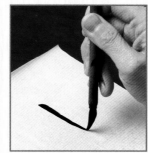

DOT

There is not a single moment in calligraphy where the brush can be allowed to rest on the paper—not even when writing a dot. Pull the tip of the brush from the starting point and then ti (lift) the brush, tucking it underneath the short stroke.

STRAIGHT STROKES

A stroke will be flat and lifeless if you don't ti (lift) your brush when performing a horizontal or vertical stroke. When you near the end of your stroke, lift the brush so that the tip can return to close the stroke.

THE POINTED END OF A STROKE

Whenever a stroke ends in a point, be sure to ti the brush. To achieve the desired effect, you must maintain complete control of the brush until the final point of the stroke is complete.

DUN (PRESS)

This technique involves pressing the brush down without relief while drawing in a continuous movement.

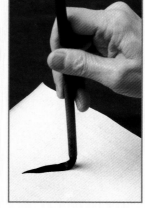 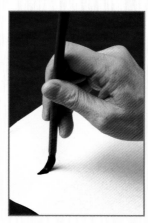

AT THE BEGINNING OF A STROKE

Press the tip of the brush down at the beginning of the stroke, and continue to push down (dun) while pulling the stroke.

DUCK'S TAIL: DOWNWARD STROKE

Some strokes have a knife-like aspect. Start by loading the brush with ink, then pressing down and pulling the brush down to the "corner" of the duck's tail.

AT THE CORNER

Change direction in a smooth movement, and pull the bristle to the right to form a point.

A BAD EXAMPLE OF TI AND DUN

In the character "ri" (sun) above, the calligrapher has not lifted the brush when negotiating the top right corner and the endings of the strokes, leaving them flat and lifeless.

A GOOD EXAMPLE OF TI AND DUN

These two characters "ri" and "yue" (sun and moon) are lively and joyful, jumping and skipping, using ti and dun to move around the strokes.

HORIZONTAL AND VERTICAL STROKES

Calligraphic strokes should be crisp, sharp, and energetic, as if chiseled with a knife. How you choose to perform a horizontal or vertical stroke (short, long, heavy, elegant, or slightly slanted) is a matter of personal aesthetics. Nevertheless, practicing the correct form will allow you to execute a stroke however you like in the future.

HORIZONTAL STROKES

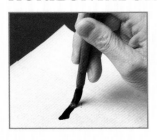

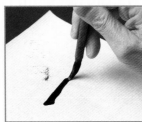

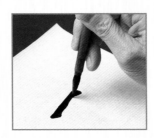

STEP 1

Place the tip of the brush on the paper to begin a horizontal stroke. Pull the brush to the right.

STEP 2

When you near the end of the stroke, lift (ti) the brush slightly.

STEP 3

Continue the movement by pulling the brush to the right, then tucking it in. To do this, complete the movement by returning the brush slightly to the left and closing the stroke.

VERTICAL STROKES

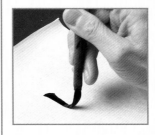

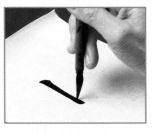

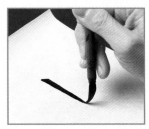

STEP 1

Begin by pointing and pushing the tip of the brush down on the paper at the top left-hand corner of the stroke.

STEP 2

If performing a straight stroke (without a point), pull the brush downward until you near the end of the stroke. Then ti (lift) the brush, returning the tip upward along the stroke.

STEP 3

If the stroke ends with a point, carry the brush straight down until near the end of the stroke. Finish by lifting (ti) the brush, gradually pulling it to a point.

DOTS

Almost like short strokes, dots contain a number of movements within a small space. A dot is written in the form of a triangle. Practice dots as if they were shortened versions of longer strokes.

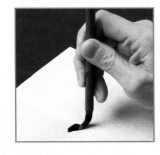

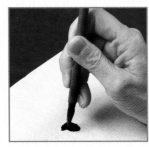

STEP 1

Place the point of the brush on the paper and pull slightly downward and to the right.

STEP 2

Lift (ti) your brush, then tuck it under the stroke by returning its point to the beginning of the dot.

FLICKS

Located at the end of a stroke, a flick is usually short and pointed upward. Each stroke is significant to its character (as well as to the entire piece of writing), so put some movement into your flick and deliver your qi right to the end of the stroke.

AT THE END OF A LONG STROKE

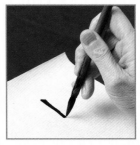

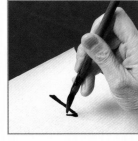

STEP 1

Place the tip of the brush below the long stroke, with the point angled left.

STEP 2

Flick upward to the left or right of the stroke (depending on the character). End with a point. Make sure the flick is chiseled, sharp, and full.

DOWNWARD SLANTING STROKE (TO THE LEFT)

Although it appears rounded, a curve should be executed in short, straight lines to give it a sense of vitality.

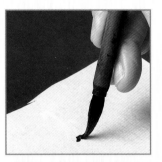

STEP 1

Tuck in the tip of the brush to the left, slanting the brush downward and to the left.

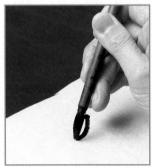

STEP 2

Deliver the stroke to the desired position. If the stroke ends with a point, lift (ti) the brush slightly, gathering the bristle into a point.

TURNING CORNERS

Chinese writing has many instances where strokes or flicks are joined to the end of another stroke. Treat them as separate strokes by lifting your brush after the first stroke and then beginning the second stroke at the corner. They should look sharp and chiseled.

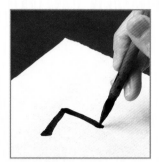

STEP 1

The first stroke is written from left to right.

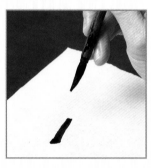

STEP 2

Add another downward stroke at the end of the first. The corner should form a crisp angle.

UPWARD SLANTING STROKE (TO THE RIGHT)

This slanting upward stroke moves right and ends in a point. Execute it with vigor. Try to use short, straight strokes for the tilting slant.

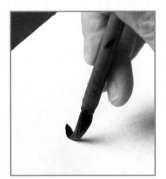

STEP 1

Tuck in the tip of the brush before executing the stroke upward and to the right. The length of the stroke needed depends on the character.

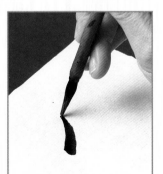

STEP 2

Make sure that the tip of the brush is carried right to the end of the stroke. End with a point.

SWEEPING DUCK'S TAIL (RIGHT)

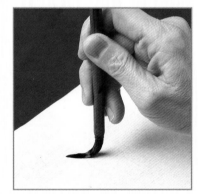

STEP 1

Tuck in the tip of the brush before starting a thin stroke, carrying it diagonally down and to the right.

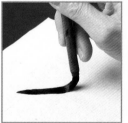

STEP 2

Apply pressure to the bottom of the brush. Pull downwards to form a corner.

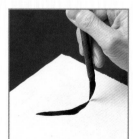

STEP 3

Continuing your former movement, pull the bristle together to form a point at the end of the stroke.

HOW TO READ A SCROLL

A scroll is usually a long sheet of calligraphy paper displaying an adage or poem written in calligraphy. There is no punctuation on a scroll. The calligrapher's name can normally be found at the end of the poem, or following a brief description of the piece of writing and the date. The calligrapher's "name seal" will appear below his/her name, while other red "leisure seals" frequently adorn the calligraphy. These can be any shape and are usually engraved with words of wisdom. Scrolls are read from top to bottom, right to left (beginning in the top right corner and ending in the bottom left corner).

HORIZONTAL SCROLL

This scroll is by Feng Tzu Chan and is a poem written by him in Seal Script.
It describes why he is blessed to live in the beautiful city of Vancouver.

The two seals here, by the side of the artist's name, are usually engraved with his or her name. Chinese artists usually have two names, or more. One is given by the parents, the other one is used only in the context of calligraphy, painting, or poetry.

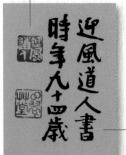

The calligrapher signs his or her work, as in this piece by Feng Tzu Chan (Yin Feng Dao Ren at 94 years old).

Start reading here and work downward, reading from right to left.

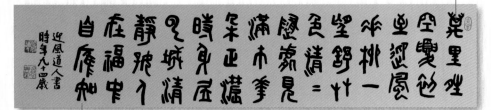

Finish reading here.

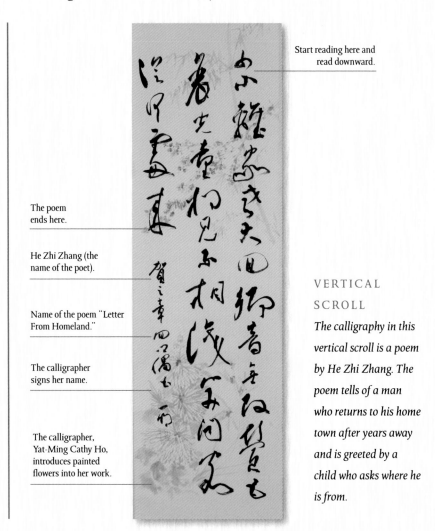

Start reading here and read downward.

The poem ends here.

He Zhi Zhang (the name of the poet).

Name of the poem "Letter From Homeland."

The calligrapher signs her name.

The calligrapher, Yat-Ming Cathy Ho, introduces painted flowers into her work.

VERTICAL SCROLL

The calligraphy in this vertical scroll is a poem by He Zhi Zhang. The poem tells of a man who returns to his home town after years away and is greeted by a child who asks where he is from.

HOW TO USE THIS SECTION

Now that you've read about brushstroke techniques, begin practicing them with numbers (see page 74), as these are the easiest to master. Once you feel comfortable, then use your newly developed calligraphy skills with words.

KEY TO CHARACTER FORMATION
- Direction of stroke
- Current stroke
- Previous strokes

TRANSLITERATION GUIDE

This shows the word written using the Roman alphabet, including stress syllables to help with pronunciation.

CHARACTERS

Lots of Chinese words have one, two or sometimes even three characters for the meaning of one English word.

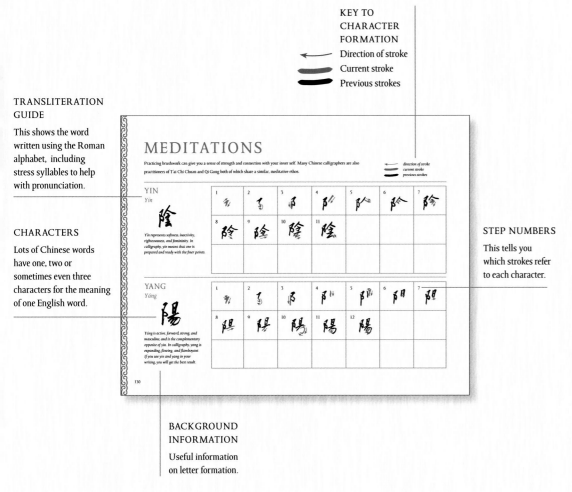

MEDITATIONS

Practicing brushwork can give you a sense of strength and connection with your inner self. Many Chinese calligraphers are also practitioners of T'ai Chi Chuan and Qi Gung both of which share a similar, meditative ethos.

- direction of stroke
- current stroke
- previous strokes

YIN
Yin

陰

Yin represents softness, inactivity, righteousness, and femininity. In calligraphy, yin means that one is prepared and ready with the finer points.

YANG
Yáng

陽

Yáng is active, forward, strong, and masculine, and is the complementary opposite of yin. In calligraphy, yang is expanding, flowing, and flamboyant. If you use yin and yang in your writing, you will get the best result.

130

STEP NUMBERS

This tells you which strokes refer to each character.

BACKGROUND INFORMATION

Useful information on letter formation.

MIXING PHRASES AND WORDS

In this section, there are phrases to denote happiness, thoughtfulness, encouragement, spiritual fulfilment and congratulatory greetings. You can write them directly on their own, or combine two or three words together to convey an individual and meaningful greeting.

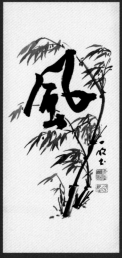

Image and word combine on this card, which says "Wind."

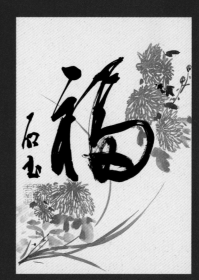

The message here is "Blessing."

The message on this card says, "Best wishes and best of luck."

NUMBERS

Chinese numbers are a great place to start practicing calligraphy. They have few strokes and are easy to master. The characters after number ten build on the numbers previously learned.

 direction of stroke
current stroke
previous strokes

ONE
Yī

Yī is a single stroke written from left to right. The stroke must be bold and deliberate.

TWO
Èr

Èr contains two strokes written from left to right. Note that the upper stroke is shorter than the one below.

THREE
Sān

Ensure that the middle stroke is the shortest, leaving space for the other two.

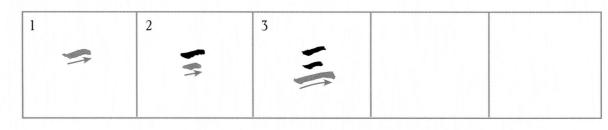

FOUR
Sì

Make sure to complete the lower horizontal stroke last, to close the box.

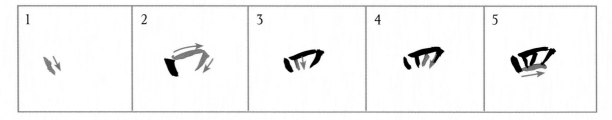

FIVE
Wŭ

The vertical strokes of wŭ sit comfortably on the long bottom stroke.

五

1	2	3	4	5

SIX
Liù

The "dot" or "short stroke" of this number is written in three stages: press the tip of the brush down, pull, and then tuck in the tip to form a triangle.

六

1	2	3	4	

SEVEN
Qī

When writing the second stroke of this character, make sure you lift the tip of the brush for the bend before pulling to the right.

七

1	2			

EIGHT
Bā

Both two strokes are written downward to form a stable stand.

八

1	2			

NINE
Jiŭ

Jiŭ has a long stroke bending to the right. Remember to lift the tip of the brush when writing a curved line. Add the flick only after you have completed the previous stroke.

九

1	2	3	4	

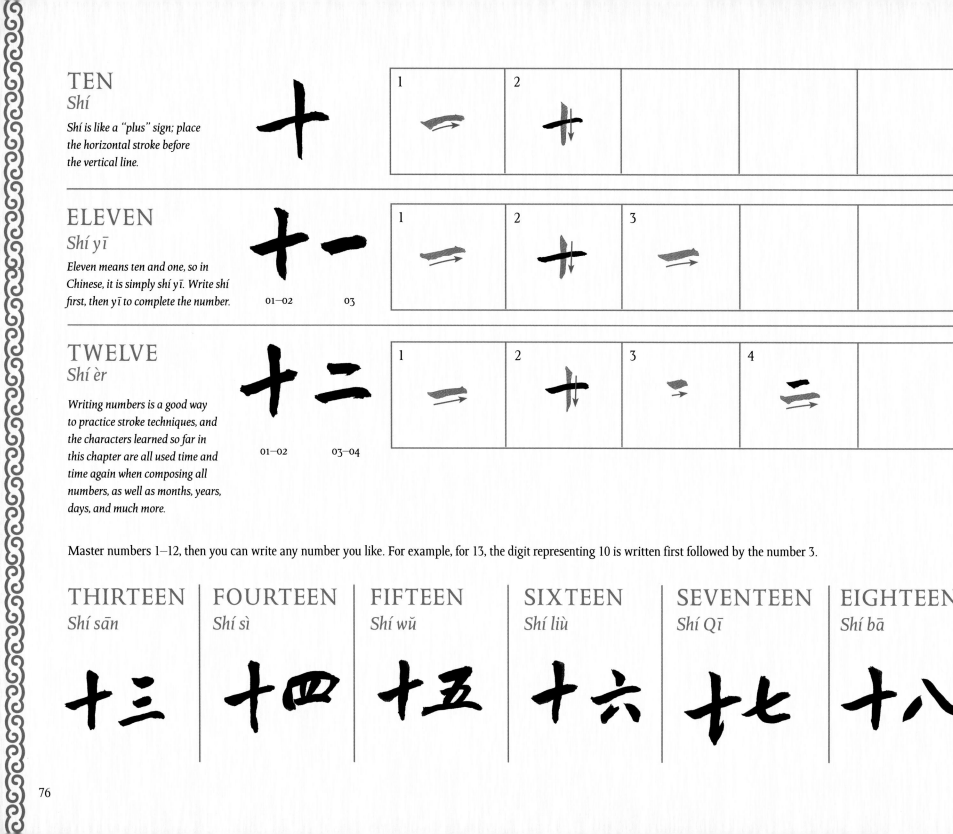

TEN
Shí

Shí is like a "plus" sign; place the horizontal stroke before the vertical line.

ELEVEN
Shí yī

Eleven means ten and one, so in Chinese, it is simply shí yī. Write shí first, then yī to complete the number.

01–02 03

TWELVE
Shí èr

Writing numbers is a good way to practice stroke techniques, and the characters learned so far in this chapter are all used time and time again when composing all numbers, as well as months, years, days, and much more.

01–02 03–04

Master numbers 1–12, then you can write any number you like. For example, for 13, the digit representing 10 is written first followed by the number 3.

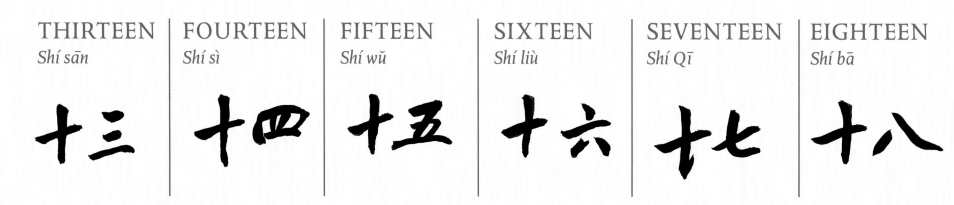

THIRTEEN
Shí sān

FOURTEEN
Shí sì

FIFTEEN
Shí wǔ

SIXTEEN
Shí liù

SEVENTEEN
Shí Qī

EIGHTEEN
Shí bā

NINETEEN	TWENTY	TWENTY-ONE	THIRTY	FORTY
Shí jiŭ	*Èr shí*	*Ér shí yī*	*Sān shí*	*Sì shí*
十九	二十	二十一	三十	四十

FIFTY	SIXTY	SEVENTY	EIGHTY	NINETY
Wŭ shí	*Liù shí*	*Qī shí*	*Bā shí*	*Jiŭ shí*
五十	六十	七十	八十	九十

ONE HUNDRED
Yī băi

Băi means hundred. One hundred is yī băi, two hundred is èr băi, three hundred is sān băi, and so on.

一百

01—02 03—07

1	2	3	4	5
一	一	丆	丆	百
6	7			
百	百			

THOUSAND
Qiān

千

Qiān contains only three strokes. Write in the right order and with the right posture. Five thousand is written as wŭ qiān.

1	2	3		
丿	二	千		

77

PEOPLE

There are different ways to address relatives on the maternal and paternal sides of a family. Relations on the sister's, daughter's or mother's side contain the character "wài" ("outside") to indicate that they don't share the ancestral surname.

← direction of stroke
— current stroke
— previous strokes

GRANDFATHER
Zǔ fù

01—09 10—13

The left-hand character of zǔ is finely balanced; notice the placing of vertical stroke 3, forming a fulcrum.

1	2	3	4	5	6	7
8	9	10	11	12	13	

FATHER
Fù Qīn

01—04 05—19

"Bà ba" is often used casually at home when speaking to one's father, but the example here, "fù qīn," is the more formal expression. "Qīn" means "affectionate" and is also used in the context of "mother" as well as the parents of the in-laws.

1	2	3	4	5	6	7
8	9	10	11	12	13	14
15	16	17	18	19		

GRANDMOTHER

Zŭ mŭ

01–09 10–14

The left side of "zŭ" indicates the meaning "ceremonial and seniority." Hence, zŭ is used for words in the context of ancestors.

1	2	3	4	5	6	7
8	9	10	11	12	13	14

MOTHER

Mŭ Qīn

01–05 06–19

"Mā mā" is the informal way of addressing one's "Mom," whereas "mŭ qīn" is the more formal expression. These two characters have very different forms, with one having far fewer strokes than the other. Treat them in the same way so that they completely fill the space in the block with the strokes available. Make sure that the characters look well balanced.

1	2	3	4	5	6	7
8	9	10	11	12	13	14
15	16	17	18	19		

SON

Ér zĭ

01–08 09–11

If you follow the step-by-step guide, you will find that all the strokes will fit and coexist comfortably in the square. The two characters occupy the whole square, so the strokes have plenty of space to show off their movements.

1	2	3	4	5	6	7
8	9	10	11			

MATERNAL GRANDFATHER

Wài zǔ fù

外祖父

01–05 06–14 15–18

The first 3 strokes of wài are supported by the upright, and balanced by the final outward stroke.

1	2	3	4	5	6	7
8	9	10	11	12	13	14
15	16	17	18			

MATERNAL GRANDMOTHER

Wài zǔ mǔ

外祖母

01–05 06–14 15–19

A maternal grandmother is addressed as "wài zǔ mǔ." The character "wài," meaning outside, is added whenever the relatives of a mother, daughter, or sister are addressed.

1	2	3	4	5	6	7
8	9	10	11	12	13	14
15	16	17	18	19		

DAUGHTER

Nǚ ér

01–03 04–11

"Nǚ" means "female" and "ér" is someone "dear" or "little." The sweeping strokes of each character can be lengthened to create a feeling of balance.

1	2	3	4	5	6	7
8	**9**	**10**	**11**			

BROTHER

Xiōng dì

01–05 06–13

The example shown here is for "older and younger brothers." The first character, xiōng,

means "older brother." and dì means "younger brother." Xiōng dì are often used together to describe one's siblings. An older brother is also addressed as "gē gē" and a younger brother as "dì dì."

1	2	3	4	5	6	7
8	**9**	**10**	**11**	**12**	**13**	

SISTER

Zǐ mèi

01–08 09–16

Both characters have "female" on their left, but can be written with variation in the brush treatment to add visual interest. The right-hand elements in both cases have vertical structures, but the base "flick" is optional.

1	2	3	4	5	6	7
8	**9**	**10**	**11**	**12**	**13**	**14**
15	**16**					

HUSBAND

Zhàng fū

01—03 04—07

The characters "zhàng fū" have only a few strokes. However, each character has two sweeping strokes that should be extended so they appear elegant and lively.

1	2	3	4	5	6	7

WIFE

Qī zǐ

妻子

01—08 09—11

Ensure that the lower horizontal of qī (step 8) is widest, part of the "female" symbol, supporting the upper structure and balanced by the diagonals below. For zǐ, enjoy the kick on step 10, which, if written in Running Script would link onto the final horizontal.

1	2	3	4	5	6	7
8	9	10	11			

GRANDCHILD

Sūn

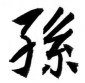

Again, zǐ is seen on the left side of this character. If you wish to indicate a maternal grandchild, wài should be added in front, as in wài sūn.

1	2	3	4	5	6	7
8	9	10				

COUSIN

Biǎo gē

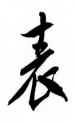

Notice that the lower vertical of biǎo is not in line with the upper one; this allows space to balance the final right-hand strokes, which finish with a dramatic diagonal sweep.

1	2	3	4	5	6	7
8						

GODPARENTS

Jiào fù mǔ

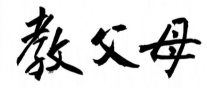

01—11 12—15 16—20

Jiào means "teach" and fù mǔ means "parents." Jiào has two parts. The left side combines xiao, meaning "piety," with zi, meaning "young child." Its right side means "to softly strike with a stick."

1	2	3	4	5	6	7
8	9	10	11	12	13	14
15	16	17	18	19	20	

NEIGHBOR

Lín jū

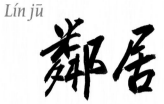

01–15 16–23

Lín means "close by" or "next to," and jū means "residence." Chinese characters are varied, combining different elements. Some of them can be simple with just a few strokes, while others may have many strokes joined together. Lín has many more strokes on the left side than on the right. Allow enough space on the left side so that it is not cramped.

1	2	3	4	5	6	7
8	9	10	11	12	13	14
15	16	17	18	19	20	21
22	23					

STUDENT

Xué shēng

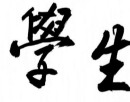

01–16 17–21

For xué, use fine brushstrokes to assemble all the detail in the top of this character, which would be top heavy if the proportions of the cover and its "child" were not large enough.

1	2	3	4	5	6	7
8	9	10	11	12	13	14
15	16	17	18	19	20	21

84

TEACHER

Lǎo shī

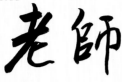

01–06 7–16

The placing of strokes for lǎo in steps 5–6 is a counterbalancing exercise dictated by the long, separating diagonal. For shī, the final down stroke of the right-hand character extends below its neighbor, with its crossbar above the center.

1	2	3	4	5	6	7
8	9	10	11	12	13	14
15	16					

LOVER

Qíng rén

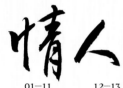

01–11 12–13

1	2	3	4	5	6	7
8	9	10	11	12	13	

For qíng, keep the middle of the three horizontals narrowest (steps 4–7). Do not close the rectangle at the bottom by overdoing the flick.

FRIEND

Péng yǒu

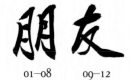

01–08 09–12

1	2	3	4	5	6	7
8	9	10	11	12		

When writing yǒu, ensure that the final extending stroke is strong and swells, then tapers at the end.

THE RAT

A long time ago, Buddha held a contest to decide the names of the Chinese calendar years. All the animals were invited to join the river race. The clever Rat rode across the river on the Ox's back; then it jumped to shore first! People born in the year of the Rat are said to share its characteristics: They are charming, talkative, and talented. The Rat's motto is "I lead."

YEARS OF THE RAT
1924, 1936, 1948, 1960,
1972, 1984, 1996, 2008

THE OX

Because the strong Ox was also simple and trusting, it fell for the Rat's trick. By offering the Rat a ride, the Ox lost first place in the 12-year calendar cycle. Instead, the Ox came in second. People born in the year of the Ox are said to share its characteristics: They are strong, patient, and thoughtful. The Ox's motto is "I carry on."

YEARS OF THE OX
1925, 1937, 1949,
1961, 1973, 1985,
1997, 2009

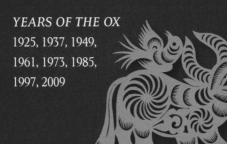

CHINESE ZODIAC

Pictograms of animals are generally constructed according to their shapes, and each represents a Chinese zodiac sign. The easy step-by-step instructions take you through even the most complicated forms.

RAT

Shŭ

This character is symmetrical until the final extended flourish, which perhaps resembles a rat's tail!

1	2	3	4
5	6	7	8
9	10	11	12
13			

OX

Niú

Niú involves only four steps. Be sure to direct your brush firmly and decisively onto the paper and to direct energy to the end of the stroke.

1	2	3	4

TIGER

Hǔ

You can see the strength and determination of the tiger in this character. Extend the last stroke in step 8 to balance the whole character.

1	2	3	4
5	6	7	8

RABBIT

Tù

This peace-loving creature is depicted by the character tù. A strong back leg is added in step 8. Don't forget to add a dot in step 9.

1	2	3	4
5	6	7	8
9			

THE TIGER

The current was strong, so the Tiger had to swim very hard to make it across the river to appear before Buddha. The panting Tiger reached the shore just after the Ox, taking the third spot in the calendar cycle. People born in the year of the Tiger are said to share its characteristics: They are kind, hard working, and independent. The Tiger's motto is "I win."

YEARS OF THE TIGER
1926, 1938, 1950, 1962, 1974, 1986, 1998, 2010

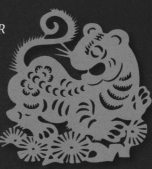

THE RABBIT

The Rabbit was too small to swim against the river's strong current, so it crossed the water by hopping from stone to stone. But the Rabbit slipped. Luckily it saw a log floating past and was able to grab on to it! The Rabbit hopped from the log to the shore to reach Buddha fourth. People born in the year of the Rabbit are said to share its characteristics: They are artistic, considerate, and modest. The Rabbit's motto is "I cooperate."

YEARS OF THE RABBIT
1927, 1939, 1951, 1963, 1975, 1987, 1999, 2011

87

THE DRAGON

The Dragon came flying in fifth. Buddha was surprised that the magical beast was not first, so the Dragon explained its delay. First the Dragon stopped to help the people and creatures of the world by making rain. Then the Dragon saw a rabbit clinging to a log, so it paused to push the helpless animal to shore with a mighty puff of breath. People born in the year of the Dragon are said to share its characteristics: They are lively, captivating, and wise. The Dragon's motto is "I rule."

YEARS OF THE DRAGON
1928, 1940, 1952,
1964, 1976, 1988,
2000, 2012

THE SNAKE

The sound of galloping hooves announced the arrival of the Horse. But the crafty Snake was hidden under the Horse's hoof! It quickly slithered out to take sixth place in the 12-year cycle. People born in the year of the Snake are said to share its characteristics: They are philosophical, fashionable, and amusing. The Snake's motto is "I feel."

YEARS OF THE SNAKE
1917, 1929, 1941, 1953,
1965, 1977, 1989, 2001

DRAGON
Lóng

龍

You can almost see the dragon in this character, lóng, which seems to have legs, horns and tails flying all over the place. The extended horizontal stroke on the left is balanced by the long curved stroke on the bottom right, which is weighted down with three more strokes.

1	2	3	4
5	6	7	8
9	10	11	12
13	14	15	16
17	18		

SNAKE
Shé

蛇

The right-hand character is larger than the left, and has a more dynamic shape with the final curve.

1	2	3	4
5	6	7	8
9	10	11	

HORSE

Mǎ

The character mǎ originated from a pictogram; the legs of the horse are still discernible here, though they have now been reduced to four dots. Chinese calligraphers try to create subtle differences within the strokes without causing too much disturbance. Try to get the dots to greet each other, to create a feeling of continuity.

1	2	3	4
5	6	7	8
9	10	11	

RAM

Yáng

The ram is a gentle, sensitive animal. The two horns depicted in the character are written downwards; the last horizontal stroke is the longest, to balance the figure.

1	2	3	4
5	6		

THE HORSE

The Horse was frightened by the sudden appearance of the Snake, causing it to fall back. But the Horse recovered quickly from its fear and galloped toward Buddha to claim seventh place. People born in the year of the Horse are said to share its characteristics: They are enthusiastic, agreeable, and curious. The Horse's motto is "I control."

*YEARS OF
THE HORSE*
1918, 1930, 1942, 1954,
1966, 1978, 1990, 2002

THE RAM

The Ram, the Monkey, and the Rooster arrived together. The three animals used teamwork to cross the river. The Ram cleared the weeds that blocked the trio's way. So Buddha granted the Ram eighth place. People born in the year of the Ram are said to share its characteristics: They are creative, gentle, and understanding. The Ram's motto is "I depend."

*YEARS OF
THE RAM*
1919, 1931, 1943,
1955, 1967, 1979,
1991, 2003

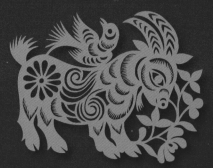

THE MONKEY

Buddha granted the Monkey ninth place in the 12-year cycle. The Monkey helped his friends the Ram and the Rooster cross the river by tugging and pulling on a raft they found. People born in the year of the Monkey are said to share its characteristics: They are inventive, cooperative, and intelligent. The Monkey's motto is "I entertain."

*YEARS OF
THE MONKEY*
1920, 1932, 1944, 1956,
1968, 1980, 1992, 2004

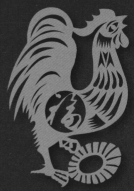

THE ROOSTER

Buddha awarded the Rooster the tenth position in the calendar cycle. The Rooster was responsible for finding the raft that carried its friends—the Goat and the Monkey—across the river. People born in the year of the Rooster are said to share its characteristics: They are friendly, adventurous, and loyal. The Rooster's motto is "I know better."

*YEARS OF
THE ROOSTER*
1921, 1933, 1945, 1957,
1969, 1981, 1993, 2005

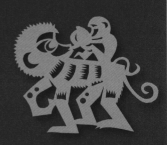

MONKEY
Hóu

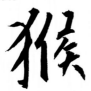

This intelligent character is agile in its movements. The right part of the character has a man on its left with bows and arrows at the bottom of the tree, ready to shoot. The left side often appears in characters relating to animals.

1	2	3	4	5
6	7	8	9	10
11	12	13		

ROOSTER
Jī

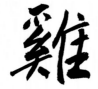

The left component of this character, according to the old form, means "big stomach" and its right side means "bird." The central upright strokes separate and balance the busier left-hand character, and are echoed more gently in the right-hand element.

1	2	3	4	5
6	7	8	9	10
11	12	13	14	15
16	17	18		

DOG

Gǒu

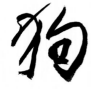

The dynamic diagonal strokes are complemented by the curved strokes in this lively character.

1	2	3	4
5	6	7	8

PIG

Zhū

This character has two parts; its left side indicates "pig," while its right side gives the phonetics of the character. Remember that you are writing one character, not two. Shorten the strokes on the left side so that those on the right side can be positioned close by.

1	2	3	4
5	6	7	8
9	10	11	12
13	14	15	

THE DOG

The Dog found the cool, fresh water of the river distracting. In fact, the river was so inviting that the Dog decided to take a bath and a quick swim before crossing to the finish! Thus, although a very good swimmer, the Dog came in eleventh place. People born in the year of the Dog are said to share its characteristics: They are helpful, devoted, and intelligent. The Dog's motto is "I care."

YEARS OF THE DOG
1922, 1934, 1946, 1958,
1970, 1982, 1994, 2006

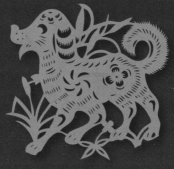

THE PIG

The Pig started the race strong, but it became hungry and tired. So the Pig stopped for a bite to eat and a nap! But the Pig was lucky enough to wake up in time to reach Buddha, taking the last place in the 12-year calendar. People born in the year of the Pig are said to share its characteristics: They are sweet, caring, and outgoing. The Pig's motto is "I keep trying."

YEARS OF THE PIG
1923, 1935, 1947, 1959,
1971, 1983, 1995, 2007

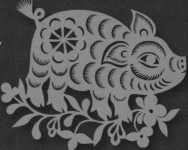

GREETINGS AND SALUTATIONS

Formal and informal terms of address and greeting are invaluable in calligraphy, as well most other forms of communication.

They will occur in letters, scrolls, and poetry to pass on sentiment, pleasure, or excitement.

direction of stroke
current stroke
previous strokes

GOOD DAY

Jīn tiān hǎo

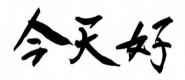

01–05 06–15

The first two characters both have strong diagonals which give liveliness to the writing; pay attention to the end of the stroke to obtain a fine point.

1	2	3	4	5	6	7
8	9	10	11	12	13	14
15						

HELLO

Nǐ hǎo

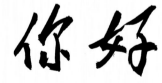

01–07 08–13

The two characters each have two parts, all with similar numbers of strokes, so this should not present problems with balancing proportions.

1	2	3	4	5	6	7
8	9	10	11	12	13	

HOW ARE YOU?
Nǐ hǎo má

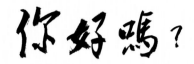

01—07 08—13 14—26

When you enquire about someone's well-being, nǐ hǎo má? ("How are you?") is used to express your concern. Má has a "mouth" (kou) on its left side and "horse" (má) on its right side. This exclamation is used as a means of expressing a question. Kou can be written a little higher, leaving enough room for the four dots at the bottom.

1	2	3	4	5	6	7
8	9	10	11	12	13	14
15	16	17	18	19	20	21
22	23	24	25	26		

GOOD-BYE
Zài jiàn

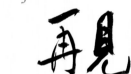

01—06 07—13

Zài jiàn literally means "See you again." The first character, zài ("again"), has three horizontal strokes, of which the bottom is the longest in order to balance the weight of the others. Jiàn means "see." The top component means "eye," which sits on top of a "person" – the two sweeping strokes below.

1	2	3	4	5	6	7
8	9	10	11	12	13	

BEST WISHES

Zhù fú

01—09 10—22

Both characters have the same elements on their left side to indicate the meaning of prayers or wishes. In order to make the characters look artistic, the writing of the two elements on the left side can be different. Here, zhù has been written using Xin Shu (Running Script), in which the strokes are linked, while the other side is written formally using the stroke-by-stroke Kai Shu style.

1	2	3	4	5	6	7
8	9	10	11	12	13	14
15	16	17	18	19	20	21
22						

TAKE CARE

Bǎo zhòng

01—09 10—18

Bǎo means "protect" and zhòng means "important." When Chinese people say farewell to each other, Bǎo zhòng expresses their concern and consideration toward others. For bǎo, spread the lower strokes (steps 8 and 9) so they radiate out and balance the form above the horizontal. With zhòng, the vertical stroke supports the whole structure and reaches from top horizontal to base line.

1	2	3	4	5	6	7
8	9	10	11	12	13	14
15	16	17	18			

CHEERS!
Gān bēi

01—11 12—19

This is a more informal salutation. Once you have practiced the stroke, try this in Xing Shu (Running Script) to make the characters as lively and cheerful as their meaning. Gān bēi means "dry your glass!"

1	2	3	4	5	6	7
8	9	10	11	12	13	14
15	16	17	18	19		

THANK YOU
Xiè xiè nǐ

謝 谢 你

01—16 17—27 28—34

Xiè is repeated to emphasize gratitude. In Chinese calligraphy, the shape of the character can be altered slightly when the same characters appear side by side. In the example shown here, see how the strokes on the left side of the second xiè are linked to the strokes on the right side, with the tick of the stroke linked to the last dot.

1	2	3	4	5	6	7
8	9	10	11	12	13	14
15	16	17	18	19	20	21
22	23	24	25	26	27	28
29	30	31	32	33	34	

CELEBRATIONS

The Chinese often write proverbs, idioms, or poetry as brushwork to celebrate special occasions. The list provided relates to happy occasions. Choose from them to enhance your own celebrations. Take pleasure in the creative process, but always remember to use the basic brushwork techniques.

direction of stroke
current stroke
previous strokes

HAPPY BIRTHDAY
Kuài lè shēng rì

生日快樂

01–05 06–09 10–16 17–31

Kuài lè means "happy" and shēng rì means "birthday"; rì means "day." The last character, lè, has many strokes. The top and bottom parts are equally important, although the bottom part has fewer strokes. The horizontal stroke in the middle should be long enough to support the top part comfortably.

1	2	3	4	5	6	7
8	9	10	11	12	13	14
15	16	17	18	19	20	21
22	23	24	25	26	27	28
29	30	31				

CELEBRATE
Qìng zhù

01–14 15–23

Qìng has fourteen strokes, which should be spaced with care. In the middle of qìng is the character xīn ("heart") to express that it is celebrated with love. Zhù has two components. Its left side is often used in combination with other characters to signify ceremonies and prayers.

1	2	3	4	5	6	7
8	9	10	11	12	13	14
15	16	17	18	19	20	21
22	23					

BIRTH
Dàn shēng

01–14 15–19

Dàn means "birth" and shēng means "life." The character shēng contains three horizontal strokes, with the middle stroke being the shortest. When writing in Xing Shu (Running Script), link the last two horizontal strokes with a flowing movement, carrying the brush with a sweeping move to form another stroke.

1	2	3	4	5	6	7
8	9	10	11	12	13	14
15	16	17	18	19		

ANNIVERSARY

Zhōu nián jì niàn

01–11 12–17 18–26 27–34

Zhōu nián jì niàn means "annual remembrance." Although the second and fourth characters have the same pronunciation, they have different meanings and are written differently. You will find that this is true of many Chinese characters. Note how, on the left side of the third character, jì, the three dots at the bottom are linked together. In Running Script (Xing Shu), dots can be linked together to express the significance of the characters.

1	2	3	4	5	6	7
8	9	10	11	12	13	14
15	16	17	18	19	20	21
22	23	24	25	26	27	28
29	30	31	32	33	34	

ENJOY

Xiǎng shòu

01–08 09–16

The bottom horizontal stroke of xiǎng should be long enough to give stability to the whole character. Shòu means "to accept" or "to take on." Its bottom part supports the whole character, so the two strokes can be written outwards to give strength.

1	2	3	4	5	6	7
8	9	10	11	12	13	14
15	16					

WEDDING

Hūn lǐ

01—11 12—28

Hūn lǐ means "ceremony of a marriage." Hūn has a nǚ ("female") on the left side and the sounding character hūn on the right side. The second character, lǐ, means "ceremony," its left side signifying formality. Use the fine tip of the brush to make the short multiple strokes of the right-hand element of lǐ. The long baseline supports the structure. Both these characters have complicated strokes. The more strokes there are, the shorter they must be to allow space for each other.

1	2	3	4	5	6	7
8	9	10	11	12	13	14
15	16	17	18	19	20	21
22	23	24	25	26	27	28

ENGAGEMENT

Dìng hūn

01—09 10—20

Keep the proportions of dìng balanced, especially the relative lengths of the horizontal strokes, stabilized by the strong vertical. For hūn, notice that this second character is the same as in "marriage," above, so write it again as described.

1	2	3	4	5	6	7
8	9	10	11	12	13	14
15	16	17	18	19	20	

CONGRATULATIONS
Zhù hè

01—09 10—20

Zhù has two equal parts; the left side indicates a ceremony or wishes. The strokes in the center are shorter than those on the outside, to enable the two parts to be positioned close together. The second character, hè, has both upper and lower parts; the lower half, which is bei ("shell"), acts as a support for the whole character.

1	2	3	4	5	6	7
8	9	10	11	12	13	14
15	16	17	18	19	20	

GRADUATION
Bì yè

01—11 12—23

Bì means "finished" and yè is "study" or "business." Both have a similar upright shape, with a central vertical stroke that stabilizes the whole character. To make the character look upright, you need to continue the qì – the flow of spirit – to the very end of the vertical stroke.

1	2	3	4	5	6	7
8	9	10	11	12	13	14
15	16	17	18	19	20	21
22	23					

HAPPY NEW YEAR

Xīn nián kuài lè

新年快樂

01–13 14–19 20–26 27–41

This phrase can be written vertically or horizontally, depending on the space available. In the example shown here, the characters have been written using Xing Shu (Running Script); some bold strokes are linked by thin thread-like strokes to produce a flowing, expressive style.

1	2	3	4	5	6	7
8	9	10	11	12	13	14
15	16	17	18	19	20	21
22	23	24	25	26	27	28
29	30	31	32	33	34	35
36	37	38	39	40	41	

GIFT

Lǐ wù

01–17 18–25

Lǐ wù, which means "a present for the ceremony," can be said at any special occasion. The left side of lǐ indicates formality. Take care not to let the top part of the right-hand character overwhelm the lower elements. Wù means "item." Be generous with the curve in stroke 23 so that there is space to fit the final strokes inside.

1	2	3	4	5	6	7
8	9	10	11	12	13	14
15	16	17	18	19	20	21
22	23	24	25			

RETIREMENT

Tuì xiū

01–09 10–15

The final stroke of each character sweeps downwards in order to create balance.

1	2	3	4	5	6	7
8	9	10	11	12	13	14
15						

WELCOME

Huān yíng

01–22 23–30

A host says "Huān yíng" when welcoming guests. Huān means "happy" and yíng means "to receive your arrival." The many strokes on the left side of huān are balanced by the simplicity of the right side. Of course, too much difference in size can spoil the proportion of the whole character. Remember to place the two parts close together. Some Xing Shu (Running Script) has been used here to soften the character.

1	2	3	4	5	6	7
8	9	10	11	12	13	14
15	16	17	18	19	20	21
22	23	24	25	26	27	28
29	30					

BAPTISM

Jìn lǐ

01–10 11–15

Lǐ is the same character that was used in "gift" (lǐ wù), but with far fewer strokes. The simplified form has been used in this example, where the right side of the traditional writing of lǐ has been simplified into one stroke.

1	2	3	4	5	6	7
8	9	10	11	12	13	14
15						

AFFIRMATIONS

You may notice that sometimes more than one character is used to represent an expression. Each character can be combined with others to produce a range of meanings, extending the vocabulary. Look at the following list and see if you can spot the same character combining with others in different expressions.

direction of stroke
current stroke
previous strokes

GROWTH

Shēng zhǎng

01–05 06–13

1	2	3	4	5	6	7
8	9	10	11	12	13	

These characters have "linking threads" (brush movement between strokes) between steps 4–5 and 6–7. These threads give a continuous flow of movement in writing, so that the piece has a wonderful feeling of growth.

COURAGE

Yǒng Qì

01–09 10–19

1	2	3	4	5	6	7
8	9	10	11	12	13	14
15	16	17	18	19		

The first character, yǒng, has the shape of lì ("strength") below its upper-sounding element, indicating that a sense of courage is needed. Qì is the "life force" and is a word we like to use nowadays to describe "the essence of life." Its top and the curved stroke downwards to its right mean "the movement of clouds." Mi ("rice") in the middle is what generates the life force.

KINDNESS

Rén cí

01–04　　05–17

When writing rén, make a "person" (steps 1 and 2) as bold structural marks next to the number two. For cí, fit the two columns of repeated strokes compactly under the horizontal; notice that from stage 14, "heart" (seen also in Love) is balanced underneath.

1	2	3	4	5	6	7
8	9	10	11	12	13	14
15	16	17				

HEALTH

Jiàn kāng

01–10　　11–21

Jiàn has two components. The left side means "person," and the right side gives the sound jiàn. The latter part has five horizontal strokes, the second of which should be the longest. For kāng, as with Jiàn, make the second horizontal the longest of the three. The vertical stroke must be long enough to anchor the final lively diagonals.

1	2	3	4	5	6	7
8	9	10	11	12	13	14
15	16	17	18	19	20	21

LOVE

Ài

Keep the second horizontal stroke, made in three movements, wide enough to cover the more complex structure of the middle part, *xīn* ("heart;" watch for this in other characters). The bottom section ends with a strong diagonal.

1	2	3	4	5	6	7
8	9	10	11	12	13	

HARMONY

Hé xié

01—08 09—24

Hé means "gentle" and *xié* means "stay together happily." When you write characters that have between two and four components, make sure they are not too far apart from one another.

1	2	3	4	5	6	7
8	9	10	11	12	13	14
15	16	17	18	19	20	21
22	23	24				

FORGIVE

Shù xīn

All of the strokes up to step 6 form two compact units; underneath these you may recognize the "heart" character (last seen in Kindness, page 105) placed symmetrically.

1	2	3	4	5	6	7
8	9	10				

EXPLORE

Tàn cè

01—11 12—22

Tàn cè means "explore." It also implies "to seek and measure." Tàn has a "hand" on its left side to indicate movement. Any character with this component always depicts action. Cè means "test." It has "water" on its left because it was used to describe "measure the deep." Its middle and right components (a shell and a knife) give the character its sound. To make the character look well-balanced, the middle part can be shorter than the other two.

1	2	3	4	5	6	7
8	9	10	11	12	13	14
15	16	17	18	19	20	21
22						

107

BRAVE

Yǒng gǎn

01—09 10—21

The first character, yǒng, has the sound element of yǒng on top, which gives the meaning of "gushing out." Gǎn means "strive forward" and "dare." It has two parts; both indicate "hands." The strokes in steps 17 and 21 expand outwards to balance the character.

1	2	3	4	5	6	7
8	9	10	11	12	13	14
15	16	17	18	19	20	21

ACHIEVEMENT

Chéng jiù

01—06 07—18

Chéng jiù means "success in whatever you do." The first character, chéng, has a long slanting stroke to the right, balancing its left side with a slightly longer stroke. The two components of the character jiù combine straight and curved lines. To put them side by side, so that you are writing one character rather than two, make the stroke in step 15 close to the first half, so that the two sides of the character counterbalance one another.

1	2	3	4	5	6	7
8	9	10	11	12	13	14
15	16	17	18			

LOYALTY

Zhōng

The sweeping stroke in step 6 is written with the tip of the brush lifted slightly to form a curve with a flick at the end.

1	2	3	4	5	6	7
忄	凹	口	中	中	忠	忠
8 忠						

SINCERE

Zhēn chēng

01–10 11–23

Zhēn means "real" and *chēng* means "genuine and honest." When they are put together, they mean "sincere" – although *chēng* can also be used on its own, with the same meaning. The two dots at the bottom of *zhēn* balance the whole form of the character.

1	2	3	4	5	6	7
一	十	吉	吉	直	直	直
8 真	9 真	10 真	11 丶	12 亠	13 言	14 言
15 言	16 言	17 言	18 訁	19 訁	20 訮	21 誠
22 誠	23 誠					

109

ENCOURAGEMENT

Gŭ lì

1–13 14–30

Gŭ ("to drum" or "to beat") and lì ("to work hard") together mean "encouragement." The many strokes in the characters convey the message of force. Deal with the strokes with the same kind of drive, making sure that the parts stay close together in a block so that they are not mistaken for more than two characters.

1	2	3	4	5	6	7
8	9	10	11	12	13	14
15	16	17	18	19	20	21
22	23	24	25	26	27	28
29	30					

STRENGTH

Lì liàng

力量

01–02 03–14

Lì ("strength") is also found in the characters for Dedication and Brave. Balance the proportions of liàng; link the strokes for softer writing.

1	2	3	4	5	6	7
8	9	10	11	12	13	14

RESPECT
Zūn jìng

01–13 14–26

Zūn is a taller character than jìng, but the latter is wider. The difference in the shape of the characters often contributes to the beauty of the whole piece of writing. Maintain the symmetry and parallel lines in zūn to contrast this character with jìng.

1	2	3	4	5	6	7
8	9	10	11	12	13	14
15	16	17	18	19	20	21
22	23	24	25	26		

HAPPINESS
Kuài lè

01–07 08–22

Kuài lè means "happy." Kuài in itself means "fast" and lè is "music" or "happy." Kuai has a "heart" (xīn) on its left, and the element at its right means "a hand" and "separate." Lè is heavy on top, so the horizontal stroke in the middle is an important element to balance the character.

1	2	3	4	5	6	7
8	9	10	11	12	13	14
15	16	17	18	19	20	21
22						

DECISION

Jué dìng

01–07 08–15

The curved vertical of jué comes full height to stabilize the right-hand part of the character. For dìng ("settled"), make the final diagonal strokes powerful, with the right-hand one longer than the left.

1	2	3	4	5	6	7
8	9	10	11	12	13	14
15						

DILIGENT

Kè kǔ

01–08 09–17

When writing kè ("to dig deep"), balance the widths of the parallel strokes stacked above each other, and match their height with the last vertical stroke of the "knife," which is step 8. Kǔ is a symmetrical character with two crosses on top counterbalanced by the smaller closed form at the bottom.

1	2	3	4	5	6	7
8	9	10	11	12	13	14
15	16	17				

POWER

Quán

This character is composed mainly of straight lines. In order to make the writing look softer, you can link the strokes in steps 21 and 22.

1	2	3	4	5	6	7
8	9	10	11	12	13	14
15	16	17	18	19	20	21
22						

DISCOVER

Fā xiàn

01–13 14–24

For xiàn, write these two elements close enough to read as one character, and finish with a final sweeping stroke.

1	2	3	4	5	6	7
8	9	10	11	12	13	14
15	16	17	18	19	20	21
22	23	24				

EMPOWER

Cù shǐ

01–09 10–17

Cù means "drive" and shǐ means "to enable," so together cù shǐ means "empower." For cù, apply pressure to thicken the end of the last stroke. When writing shǐ, apply pressure to the final diagonal to make it strong.

1	2	3	4	5	6	7
8	9	10	11	12	13	14
15	16	17				

CREATE

Chūang zuò

創作

01–12 13–19

The sound element of chūang ("to create" or "to injure") is on the left side of the character, while a knife is at its right side. Zuò is "do"; the right side means "an immediate reaction." The character for "person" appears on the left side. Make the "person" character, then the remaining part, taking care to fuse these as one unit.

1	2	3	4	5	6	7
8	9	10	11	12	13	14
15	16	17	18	19		

STRIVE FORWARD

Zhēng qǔ

01–06 07–14

Zhēng means "to fight for one's desire" and qǔ is "to take." The horizontal stroke and the central vertical stroke in zhēng balance the character with their firm stances. Qǔ has a smaller element on its right and is shielded by the upper long horizontal stroke.

1	2	3	4	5	6	7
8	9	10	11	12	13	14

INTELLIGENCE

Cái zhì

01–03 04–15

Cái means "a new plant shooting up," implying a person with inner talents. Keep the upright stroke forceful and in proportion to the horizontal. The character zhì means "wisdom." Centralize the lower symbol ("sun" or "express") to balance the character.

1	2	3	4	5	6	7
8	9	10	11	12	13	14
15						

PROSPER

Shùn lì

01—11 12—18

Shùn means "moving smoothly" and lì is "benefit" or "good for" or "sharp." The left component of shùn, with three downward strokes, tells you that it is a river. Keep the middle of the first three strokes shorter; write the more complex sequence with rhythmic, even strokes. Lì has a hé ("crop") at its left and a knife at its right, indicating a harvest. The vertical stroke in step 14 stabilizes the form, so make sure it is strong.

1	2	3	4	5	6	7
8	9	10	11	12	13	14
15	16	17	18			

GOAL

Mù biāo

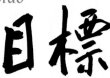

01—05 06—20

Mù, meaning "eye," developed from the pictographic image of a child's face, with eyebrow and eye. Biāo has a mù ("wood") on its left side to indicate wooden signage. Keep the vertical stroke in step 7 very long, and use the brush's point to accommodate all the detail in the right-hand element.

1	2	3	4	5	6	7
8	9	10	11	12	13	14
15	16	17	18	19	20	

EXCELLENT

Yōu xiù

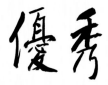

01–17 18–25

Yōu means "distinction." There is rén at its left to indicate "people's activity." The other side is yōu, which is the sound element to the character. Note that yōu ("worried") has xīn ("heart") in the middle and the bottom part means "walk." This lower element requires a strong final stroke. Xiù has hé ("crop") on top with a nai ("hard to express") below it. Xiù means "beautiful in an intellectual sense" or "excellent." Be sensitive to the direction changes, especially lift-offs.

1	2	3	4	5	6	7
8	9	10	11	12	13	14
15	16	17	18	19	20	21
22	23	24	25			

TRUSTWORTHY

Kě kào

可靠

01–05 06–20

Kě means "yes" or "positive" and kào means "reliable." From step 14 onward, the three short strokes on both vertical strokes can be written in a slightly irregular fashion to give some light relief to the character.

1	2	3	4	5	6	7
8	9	10	11	12	13	14
15	16	17	18	19	20	

HERO

Yīng xíong

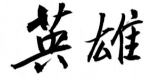

01–10 11–22

When writing yīng, spread the last strokes (steps 9 and 10) under the horizontal to balance the top. Xíong consists of two elements that must be close to each other to resemble the one character.

1	2	3	4	5	6	7
8	9	10	11	12	13	14
15	16	17	18	19	20	21
22						

RECOGNIZE

Rèn kě

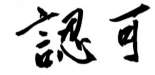

01–14 15–19

For rèn, the top-right part means "knife" and xīn ("heart") is underneath it. Putting a knife against your heart is "endurance." The left side means "to speak." Kě means "yes" or "can do." Keep the two elements close as one character while making the strokes lively, pausing at the corner of the last stroke for a flick.

1	2	3	4	5	6	7
8	9	10	11	12	13	14
15	16	17	18	19		

KINDNESS,
RIGHTEOUSNESS,
LOYALTY,
AND TRUST

Rén, yì, zhōng, xīn

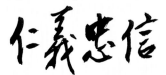

01–04 05–17 18–25 26–34

Rén ("kindness"), yì ("righteousness"), zhōng ("loyalty"), and xīn ("trust") are the four virtues traditionally needed for a man to become a gentleman. The first character, rén, depicts two people, which denotes that kindness exists between people. The character me, on the lower half of yì, connotes that the virtue of righteousness starts from oneself. "Loyalty" in Chinese is zhong: "central" is on top of "heart" (xīn), indicating that an unbiased heart is required to be a faithful and loyal person. Xīn means "trust" where "word" is next to "people," telling us that people should speak the truth.

LOVE

The brush is a vehicle for your expression. Through its responsiveness, you will come to understand your inner self.

Be prepared to surprise yourself – just pick up the brush, follow the simple instructions and see what happens.

direction of stroke
current stroke
previous strokes

COMPANION

Tóng bàn

01–06 07–13

For tóng, the central strokes are practically embraced by the outer strokes. When writing bàn, balance the lengths of the horizontals against the sturdy upright.

1	2	3	4	5	6	7
8	9	10	11	12	13	

DESIRE

Yāo qiú

01–09 10–16

Yāo means "want." The long stroke across the bottom counterbalances the character. Qiú means "acquire" or "beg." It has four slanting strokes that point inwards towards the center; the dot on the top right corner balances the whole character.

1	2	3	4	5	6	7
8	9	10	11	12	13	14
15	16					

DELIGHT

Yú kuài

01—12 13—19

There are several ways to express "delight," depending on the context. Here, it is expressed as yú kuài. Yú means "happiness." Its left component is xin ("heart"), indicating emotion. You may have noticed that xin is written differently when it is used at the left side of a character. The strokes have been stretched and lengthened.

1	2	3	4	5	6	7
8	9	10	11	12	13	14
15	16	17	18	19		

PRECIOUS

Zhen gui

01—09 10—20

Zhen means "precious." It has "jade" on its left to express the quality of this character. The sound of zhen is given by its right side, where the slanting strokes represent a woman's hair, luscious and dark. The last stroke should be the longest in order to balance the character. Gui means "expensive and precious." The top of gui is a zhong ("center and within") with a horizontal stroke across and followed by the character bei ("shell"), which was used as a form of currency in the past.

1	2	3	4	5	6	7
8	9	10	11	12	13	14
15	16	17	18	19	20	

BEAUTY

Měi

The separate stroke in the bottom half of the character should be the longest, with the two slanting strokes across it and to its right, counterbalancing the character.

1	2	3	4	5	6	7
8	9					

PASSION

Rè Qíng

01–15 16–26

The first character, rè, means "hot," while qíng means "love." Together, they mean "passion." The presence of heat is indicated by four dots ("fire").

1	2	3	4	5	6	7
8	9	10	11	12	13	14
15	16	17	18	19	20	21
22	23	24	25	26		

COMPASSION

Tǐ xù

01—23 24—32

For tǐ, use a light touch to retain the detail in these many strokes, and pay attention to relative stroke lengths. When writing xù, balance these fewer strokes against the weight of the first character.

1	2	3	4	5	6	7
8	9	10	11	12	13	14
15	16	17	18	19	20	21
22	23	24	25	26	27	28
29	30	31	32			

HEART

Xīn

With a sweeping stroke bending to the right, xīn resembles a boat. The position of the curved line is important, as the balance of the character will depend on it. Use the tip of your brush to continue the stroke, ending with two short strokes (dots) on top.

1	2	3	4		

BLISS

Zhì lè

01–06 07–21

Zhì means "extreme" and lè means "happiness." Zhì is made up of only six strokes, but four are horizontal. When spacing these strokes, leave even spaces between them so they don't look squashed. The many strokes on the top half of lè weigh down on the long horizontal stroke running through the center of the character.

1	2	3	4	5	6	7
8	9	10	11	12	13	14
15	16	17	18	19	20	21

TRUST

Xīn rèn

01–09 10–15

Xin means "trust." Ren means "good" and "kind." The character has two parts; ren, meaning person, is on the left. The right side means "perfect" or "right." This character has two horizontal strokes. The top stroke should be longer than the bottom one.

1	2	3	4	5	6	7
8	9	10	11	12	13	14
15						

GRATITUDE

Xie Yi

01–17 18–30

The character xie is quite complex until you break down the components; keep them all to the same height. For yi, the second horizontal is wide and the "heart" at the bottom balances that width.

1	2	3	4	5	6	7
8	9	10	11	12	13	14
15	16	17	18	19	20	21
22	23	24	25	26	27	28
29	30					

TOGETHER

Yī qǐ

一 起

01 02–11

The right diagonal at the bottom of qǐ spreads wider than the left diagonal, to sweep underneath the right-hand element for balance.

1	2	3	4	5	6	7
8	9	10	11			

125

CARING

Xì xīn

01—11 12—15

Xì xīn is one of several ways of saying "caring." Xì means "small," while xīn is "heart." "Small heart" is used to describe a caring person. Xì has "silk" at its left, which has the meaning of "fine and delicate." On its right is tian; although it means "field," in the past, it was written and interpeted as "brain."

1	2	3	4	5	6	7
8	9	10	11	12	13	14
15						

EMBRACE

Yōng Bào

01—15 16—23

These are characters of action as indicated by the hand on the left. Delicate strokes in steps 5 to 15 balance with the hand on the left.

1	2	3	4	5	6	7
8	9	10	11	12	13	14
15	16	17	18	19	20	21
22	23					

126

CHERISH

Zhēn xī

1–09 10–20

Zhēn means "precious." A slight change in the direction of the third slanting stroke in zhēn (step 9) balances and enhances the beauty of the whole character. Xī is "to treasure." While the xī on the right gives the sound of the character, the "heart" on the left indicates emotion.

1	2	3	4	5	6	7
8	9	10	11	12	13	14
15	16	17	18	19	20	

TENDER

Wēn róu

01–12 13–21

When writing róu, keep the middle horizontal wide, and the final strokes radiating out in balance.

1	2	3	4	5	6	7
8	9	10	11	12	13	14
15	16	17	18	19	20	21

RADIANT

Míng yàn

明 豐盍

1–08 09–36

Yàn has complex structures to be built with light strokes so as to accommodate them in the space. The left side's top-heavy character is neatly counterbalanced by the bottom-heavy right-hand part.

1	2	3	4	5	6	7
8	9	10	11	12	13	14
15	16	17	18	19	20	21
22	23	24	25	26	27	28
29	30	31	32	33	34	35
36						

SYMPATHY

Tóng Qíng

01–06 07–17

The central strokes of tóng are embraced by the outer strokes. Qing includes "heart" and is a also seen in Passion on page 122.

1	2	3	4	5	6	7
8	**9**	**10**	**11**	**12**	**13**	**14**
15	**16**	**17**				

FRIENDSHIP

Yǒu yì

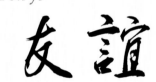

01–04 05–19

The first character, yǒu, means "friend," while yì indicates "relationship." The example above shows some links between the strokes; this is known as Xin Shu ("Running script") style. Make sure that these are just links, not strokes, so that they appear as "threads."

1	2	3	4	5	6	7
8	**9**	**10**	**11**	**12**	**13**	**14**
15	**16**	**17**	**18**	**19**		

MEDITATIONS

Practicing brushwork can give you a sense of strength and connection with your inner self. Many Chinese calligraphers are also practitioners of T'ai Chi Chuan and Qi Gung both of which share a similar, meditative ethos.

direction of stroke
current stroke
previous strokes

YIN

Yīn

Yīn represents softness, inactivity, righteousness, and femininity. In calligraphy, yin means that one is prepared and ready with the finer points.

1	2	3	4	5	6	7
8	9	10	11			

YANG

Yáng

Yáng is active, forward, strong, and masculine, and is the complementary opposite of yin. In calligraphy, yang is expanding, flowing, and flamboyant. If you use yin and yang in your writing, you will get the best result.

1	2	3	4	5	6	7
8	9	10	11	12		

SOUL

Líng hún

1–24 25–38

When writing hun, keep the two elements of the character close together, to make a unit; be generous with the stroke in step 36 to accommodate the final element.

1	2	3	4	5	6	7
8	9	10	11	12	13	14
15	16	17	18	19	20	21
22	23	24	25	26	27	28
29	30	31	32	33	34	35
36	37	38				

THOUGHT

SĪ OR XĪN

思

In the second stroke of the xīn "heart," step 7, start with the point of the brush and pay attention to the two dots on top formed in different directions.

1	2	3	4	5	6	7
8	9					

MEDITATION

Míng xiǎng

01–10 11–23

With xiāng, balance the "heart" centrally to the upper two elements, and use the point of the brush to obtain a sharp beginning to this shape.

1	2	3	4	5	6	7
8	9	10	11	12	13	14
15	16	17	18	19	20	21
22	23					

NO LIMIT

Wú jí

01–12 13–25

According to Yi Jing, The Book of Change, wú jí existed before t'ai chi. Wu means "nothing" and jí means "limit." Each of the four dots at the bottom of wú should be written slightly differently to convey movement. This applies to all the other strokes, which should show a continuation of spirit from beginning to end.

1	2	3	4	5	6	7
8	9	10	11	12	13	14
15	16	17	18	19	20	21
22	23	24	25			

REALIZATION

Wù

悟

It is wonderful when we achieve wù ("realization"). The left side of wù shows a xīn ("heart") to indicate the involvement of our inner self.

1	2	3	4	5	6	7
8	9	10				

INSIGHT

Wù lì

悟力

1—10 11—12

It can take a considerable effort to construct simple characters. The second character, lì, has only two strokes, but you will have to think ahead in order to achieve a balanced character.

1	2	3	4	5	6	7
8	9	10	11	12		

ACCEPTANCE

Jiē shòu

接受

01—11 12—19

Ensure that the vertical stroke of jiē is long enough to balance the second, more complex element. For shòu, give emphasis to the final stroke to the right, adding pressure to thicken, then taper.

1	2	3	4	5	6	7
8	9	10	11	12	13	14
15	16	17	18	19		

BELIEF

Xīn niàn

01–09 10–17

When written at speed, some of the individual strokes of *xìn* will show thin joining lines. For *niàn*, with the "heart," make the curved shape by starting with the point of the brush for a sharp beginning to the stroke.

1	2	3	4	5	6	7
8	9	10	11	12	13	14
15	16	17				

SPIRIT

Jìng shén

01–14 15–23

When you execute the strokes in *jìng shén* or any other character, the spirit that you impart is important. Let the strokes talk, salute, and greet each other. Characters without any flow of *qì* are considered not to be alive.

1	2	3	4	5	6	7
8	9	10	11	12	13	14
15	16	17	18	19	20	21
22	23					

AWAKENING

Qǐ shì

01–11 12–16

Qǐ shì means "awakening." Qǐ means "to open" and shì is "to show." The sweeping stroke to the right in step 11 is essential to create a well-balanced character.

1	2	3	4	5	6	7
8	9	10	11	12	13	14
15	16					

JOURNEY

Lǚ chéng

01–10 11–22

Follow the individual strokes to discover the structure, then develop rhythm by writing more fluidly to obtain richer writing. Running script, for example, is used in steps 21 and 22, where the last two horizontals show a joining stroke.

1	2	3	4	5	6	7
8	9	10	11	12	13	14
15	16	17	18	19	20	21
22						

MIRACLE

Qǐ Jí

01–08 09–21

Keep the second horizontal of qǐ wide to support the element above, and make the vertical a similar depth. For jí, keep the two halves close together, and balance the proportions.

1	2	3	4	5	6	7
一	大	大	大	大	奇	奇
8	9	10	11	12	13	14
奇	小	后	马	足	足	足
15	16	17	18	19	20	21
足	足	跃	跃	跃	跡	跡

IMAGINE

Xiǎng xiàng

01–13 14–27

Both of these characters are pronounced "xiāng." The first xiǎng has three elements to balance together, with the "heart" at the base filling the width. In the right-hand part of the second xiàng, keep strokes short to fit them all into the small space.

1	2	3	4	5	6	7
一	大	才	木	朴	朴	相
8	9	10	11	12	13	14
相	相	相	想	想	想	仆
15	16	17	18	19	20	21
仆	仆	仿	仔	仔	俘	侮
22	23	24	25	26	27	
侮	傍	傍	像	像	像	

INSPIRATION

Líng gǎng

1–23 24–36

The second horizontal of *líng* is the widest, and is domed. The complexity of structures beneath this requires a delicate touch with the tip of the brush. When writing *gǎng*, ensure that the diagonal (step 34) is strong enough to balance the elements to its left.

1	2	3	4	5	6	7
8	9	10	11	12	13	14
15	16	17	18	19	20	21
22	23	24	25	26	27	28
29	30	31	32	33	34	35
36						

CAREFREE

Zì zài

01–06 07–12

For *zài*, note that stroke 8 has a curve, and the horizontal is wide, allowing space for the final element to sit underneath.

1	2	3	4	5	6	7
8	9	10	11	12		

137

CALM

Píng jìng

01–05 06–19

Make the middle of the three horizontals of jìng the shortest, and the third the widest for balance. Fit the second element close and at the same height for unity.

1	2	3	4	5	6	7
8	9	10	11	12	13	14
15	16	17	18	19		

SERENITY

Níng

寧

The cover on top of níng indicates a "house," followed by a "heart" (xīn) to depict the involvement of feelings, then a min ("food container") to express a feeling of comfort and security. The horizontal stroke in step 13 resembles a long arm, stretching out to balance the whole character.

1	2	3	4	5	6	7
8	9	10	11	12	13	14

PATIENCE

Nài xīn

01–09 10–13

Xīn ("heart") has only four strokes, which can easily convey the elegance of the character when they are placed correctly.

1	2	3	4	5	6	7
8	9	10	11	12	13	

DESTINY

Mìng yùn

01–08 09–21

When writing yùn, allow sufficient space to the left when starting stroke 9 to accommodate steps 18–21, ending in a "long road" sweep across the bottom.

1	2	3	4	5	6	7
8	9	10	11	12	13	14
15	16	17	18	19	20	21

RELAX

Fàng kūan

01–08 09–21

Balance the proportions of fàng and give strength to the final diagonal stroke. For kūan, a lot of small strokes are in a confined space; sweep the final curve around and pause before the "flick" at the end, and do not forget the dot.

1	2	3	4	5	6	7
8	9	10	11	12	13	14
15	16	17	18	19	20	21

TRANQUILITY

Jìng

In the left-hand part of the character, the third horizontal completing the upper element separates the two forms. The right-hand character has a strong vertical which gives stability.

1	2	3	4	5	6	7
8	9	10	11	12	13	14

TRUTH

Zhēn xiàng

01—10 11—19

The bottom horizontal of *zhēn* is wider than the top one, for balance. When writing *xiàng*, retain the proportions of the rectangle to balance that of *zhēn*.

1	2	3	4	5	6	7
8	9	10	11	12	13	14
15	16	17	18	19		

140

FAITH

Xīn yǎng

01—09 10—15

There are relatively few strokes to these characters; concentrate on balancing the proportions and space evenly.

1	2	3	4	5	6	7
亻	亻	伩	信	信	信	信
8	**9**	**10**	**11**	**12**	**13**	**14**
信	信	亻	亻	亻	仰	仰
15						
仰						

BALANCE

Píng héng

01—05 06—21

Each character has its own way of balancing ("píng héng"). Whether it is in the handling of the brush or the spacing and structure of the strokes, the skill of the calligrapher is all-important. A dot positioned slightly out of place can spoil a well-written character. Therefore, careful thought should be given to its construction beforehand.

1	2	3	4	5	6	7
一	丆	二	平	平	彳	彳
8	**9**	**10**	**11**	**12**	**13**	**14**
彳	彳	徍	彶	徨	徫	衕
15	**16**	**17**	**18**	**19**	**20**	**21**
衡	衡	衡	衡	衡	衡	衡

VISION

Huàn xiàng

1–04 05–18

When writing huàn, balance the placing of the few strokes in this character with the complexity in xiàng. For xiàng, make small delicate strokes to fit in all the detail and finish with a strong diagonal sweep.

1	2	3	4	5	6	7
8	9	10	11	12	13	14
15	16	17	18			

WISH

Dàn yuàn

但願

1-07 08-24

With practice, you will write more quickly and fluidly, so some strokes will merge together (especially when making the rectangles) to allow a continual flow of energy.

1	2	3	4	5	6	7
8	9	10	11	12	13	14
15	16	17	18	19	20	21
22	23	24				

INDEX